IMAGES
of America

CORAL GABLES

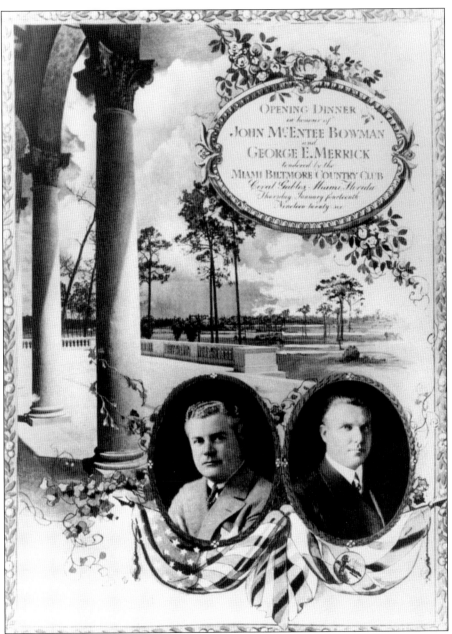

On Thursday, January 15, 1926, the magnificent Bowman Miami Biltmore Hotel opened. The previous night, the opening dinner was held to celebrate the event at the Biltmore Country Club and to honor Biltmore builder John McEntee Bowman and Coral Gables founder George E. Merrick. The cover of the menu, featuring Bowman (left) and Merrick, is presented above.

ON THE COVER: The streetcars are lined up for the first day of service, April 30, 1925, and the man standing next to number 102 is, we believe, Coral Gables' first mayor, Edward E. "Doc" Dammers, who would take his post the next day. The only things missing from Coral Gables today are these wonderful and real streetcars, which are odor and pollution free and, compared to the busses, almost noiseless.

IMAGES
of America

CORAL GABLES

Seth H. Bramson

ARCADIA
PUBLISHING

Published by Arcadia Publishing
Charleston, South Carolina

Printed in the United States of America

Library of Congress Catalog Card Number: 2006925670

For all general information contact Arcadia Publishing at:
Telephone 843-853-2070
Fax 843-853-0044
E-mail sales@arcadiapublishing.com
For customer service and orders:
Toll-Free 1-888-313-2665

Visit us on the Internet at www.arcadiapublishing.com

They have never said "no," and have always helped anybody who had or has an interest in South Florida history, and while they have both been acknowledged many times in various tomes and articles, it is a pleasure and a privilege to be the first to dedicate a book to my longtime friends Samuel Boldrick, director emeritus of the Florida Collection of the Miami-Dade Public Library System, and Becky Smith, director of the Research Center of the Historical Museum of Southern Florida. They have both earned this honor, and with this dedication may they know how strongly and warmly every person who has come in contact with them feels toward and about them.

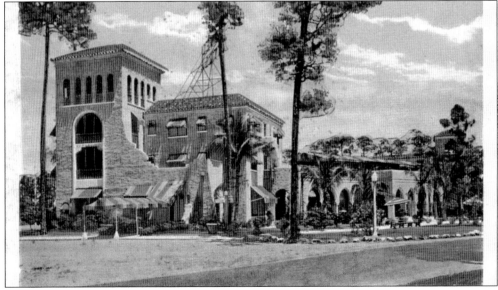

Airy and welcoming, the Antilla Hotel was for many years a Gables favorite.

CONTENTS

ACKNOWLEDGMENTS

It is with no small amount of appreciation that the author acknowledges, with great gratitude for their interest, support, patience, and willingness to help, the following: Kathryne Ashley, who so graciously gave me a copy of her wonderful book *George E. Merrick and Coral Gables, Florida*, which is the seminal writing on and about the life of Mr. Merrick and his family; Phil Spool, Mitch Rosen, and Ron Gabor of the Miami Memorabilia Collectors Club, who so generously loaned me photographs and other Gables historical items; Dan Finora, beloved coach, counselor, and mentor of decades of Coral Gables High students, for his warm greetings and the loan of four beautiful Gables High–related photographs; Simone Chin, of the City of Coral Gables Division of Historic Preservation, from whom I was able to obtain several fine images which appear herein; Vice Provost Perri Roberts, Director William Walker, and Curator Maria Estorino of Special Collections of the University of Miami, who were all eminently cordial and helpful; Bruce Hamerstrom, the dean of Little River history, who unhesitatingly loaned us several fine Coral Gables–related items; Sgt. Michael Frevola, Officer Martin Barros, and Trish Rodriguez of the Public Information Office of the Gables Police Department, who searched early records and assisted me with departmental historical information; Gloria Sobel, Nancy Martin, and so many other "Gables girls" who I dated or was friendly with, and who so enriched my memories of those great and happy years of my misbegotten youth, as I would spend untold hours and evenings with them at Jahn's on Miracle Mile, at Gables High football games, or, sometimes, at the submarine races, instead of studying for my classes at Beach High; and Mayor Donald Slesnick and City Manager David Brown for their enthusiastic support of this project; along with so many others who, while not having photographs or memorabilia, unhesitatingly offered their thoughts and insights. My thanks to every one of you!

Unless specifically credited otherwise, all photographs are from the author's collection.

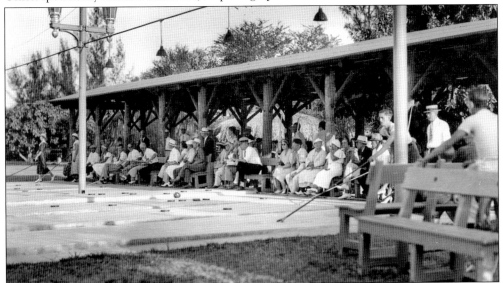

While we usually think of shuffleboard as a St. Petersburg or Miami Beach hotel pastime, Coral Gables was no slouch in providing court space for that unique sport. Here young and old alike enjoy the game at Salvadore Park. It has all changed though, and some time in the late 1960s, after interest waned, the courts, falling into disuse, were removed, the days of the shuffle boarders now but a memory.

INTRODUCTION

After enduring years of hardship and bitter winter cold in the northeast, Rev. Solomon Merrick purchased, sight unseen, the former Gregory property, 160 acres west of Coconut Grove, in 1896. Leaving Duxbury, Massachusetts, and his church, Merrick and his eldest son, George, set out for South Florida in early 1898. A yellow fever epidemic in the Miami area delayed their progress, and they spent several months with a minister friend of Reverend Merrick on the Loxahatchee River near Jupiter.

Arriving at the property—which, depending on the various reports, the elder Merrick had paid between $800 and $1,200 for—they found, much to their great dismay, that only one-half acre had been cleared and planted in guava, and the domicile, unlike their expectations, was little more than a shack.

Reverend Merrick, undeterred, immediately began clearing the land, planting vegetables, and building a home suitable for his wife, Althea, and the other four children, who would arrive in January 1900, in the midst of a horrific downpour, giving her great cause for concern about the wisdom of her husband's decision.

Solomon, however, was undeterred, and George, though not tall, was strong and solid and unafraid of hard work. Even though the reverend had spent almost all of his initial bankroll on the land, clearing, planting, and building the family's house, he, Althea, George, and the other four children dedicated and committed themselves to, in today's parlance, "making it happen."

In 1907, at age 21, George left Miami for Rollins College in Winter Park, where he would become friendly with two young men who, later in life, were to have a great influence on him; Jack Baldwin and Rex Beach, would, indeed, be part of the Coral Gables saga.

In 1908, New York beckoned, and George enrolled in the New York Law School, then part of Columbia University. Living at the home of his mother's brother, Denman Fink, would be a blessing, as Denman, a talented artist, would later do much of the Coral Gables Corporation's artwork, and George's cousin, H. George Fink, would become Merrick's architect.

H. George Fink's family moved to Miami in 1904, when the youngster was 13. He would attend architecture school at Drexel Institute and the University of Pennsylvania and would return to Miami to work for Carl Fisher, the builder of Miami Beach, designing, among other buildings, Miami Beach High School and the First National Bank of Miami Beach before becoming George Merrick's architect.

Solomon died in 1911, necessitating George's return to Florida, and by 1916, George was successfully managing the Coral Gables Plantation. On February 5 of that year, he married the great love of his life, Eunice Peacock, whose family's history is also indelibly entwined with that of South Florida, her parents owning and operating what are believed to be the first two hostelries in the Miami area, the Bay View House and the Peacock Inn in Coconut Grove.

By 1920, George had entered the real-estate business, and in addition to the fruit and produce being shipped from Coral Gables Plantation, he developed several early Miami subdivisions including North Miami Estates (not the later North Miami), Grapeland, North Coconut Grove, Goulds, Riverside Heights, and others. He was, as the saying goes, "on his way," but all of that was only a prelude to what would come.

By 1921, Coral Gables was underway, and the incredible story of the building of "the Gables" is nothing short of epic. The University of Miami applied for its charter on March 4, 1925; the city was chartered on April 29; the first streetcar of the Coral Gables Rapid Transit Company ran the next day; and on May 1, both the Coral Gables Corporation and the city came into existence, Dr. Edward E. "Doc" Dammers becoming the first mayor.

The great boom would soon bust, and by 1930, both the corporation and Merrick himself were bankrupt. Following the hurricane of November 3 and 4, 1935, the streetcar line, which had suffered immense damage, ceased operating. The recovery would begin thereafter, and the city, slowly but surely, would work its way back to prosperity.

Although the Biltmore Hotel would be taken over by the military for use as an army hospital early in World War II, and would become the VA hospital after the war, dogged persistence by the people of the city saved the hotel, and it has been restored to its former, glittering brilliance. Coral Gables, home of a great high school, the Venetian Pools, the University of Miami, and several multinational corporations, is today a city of beautiful homes, a fascinating history, and an understanding of the past as it moves steadily into the future.

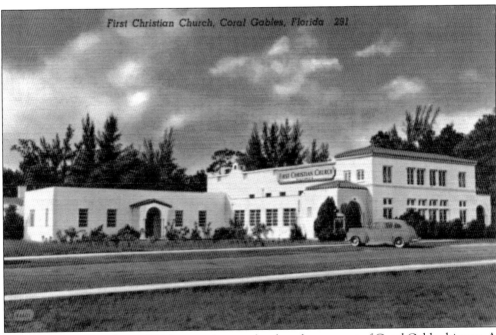

First Christian Church, at 222 Menores Avenue, has long been a part of Coral Gables history. A beautiful and historic building, the church is now home to the monthly meetings of the Miami Memorabilia Collectors Club and other civic and historic organizations.

THE CITY OF CORAL GABLES

The City Beautiful

OFFICE OF THE MAYOR

CITY HALL 405 BILTMORE WAY
CORAL GABLES, FLORIDA 33134

May 12, 2006

Dear Reader:

Our community is no different than most others; we are extremely proud of our collective heritage. The history of this city, as it unfolds in the pages of this book, is infused with the struggle of mankind to balance its needs with nature, growth, modernization and changing social mores.

Coral Gables represents the vision of one man to create an ideal American city inspired by the biblical prophecies of Ezekiel and given definition by Washington Irving's description of 19th Century Spain. George Merrick's dream has been kept alive by several generations of dedicated public servants and an involved citizenry.

All Floridians share a history of struggles against the natural challenges of hurricanes, bugs and heat. There have also been the challenges of man-made obstacles including land booms and busts, the Great Depression and the emergence of gasoline powered vehicles. All these forces have helped shape our residential and commercial neighborhoods.

Sit back, enjoy and let an all-American story unfold as you learn about a part of the last frontier on the North American continent – a place now known as the "City Beautiful".

Don Slesnick
Mayor

The early Miamians were truly pioneers, and whether male or female, living in Miami itself, Coconut Grove, or the area that would become Coral Gables, they had to be of sturdy stock. With no air conditioning, little electricity, and few comforts, sustained mostly by the camaraderie of their neighbors and the beautiful weather, they worked together to carve a civilization from the South Florida jungle.

One

THE MERRICKS COME TO MIAMI

In explaining why his family left Massachusetts, George Merrick wrote that "the street in front of [his father's] colonial parsonage was a snow canyon, the banks towering so high that Dr. Noyes, traveling horseback to his score of pneumonia patients, and standing in the stirrups, could not reach [it's] tops."

With all of New England in the grasp of the horrific blizzard of 1895, the temperature well below zero, and 40 people having died in their little Cape Cod village alone in just one week (including Merrick's baby sister), and with more at death's door, the idea of leaving Duxbury and moving to the warmth of sunny South Florida was not a difficult decision for Rev. Solomon Merrick to make.

It appears that the reverend purchased the property west of Coconut Grove in 1896, but there is some debate as to when he and George actually arrived; most accounts tell us that, although delayed by the yellow fever epidemic for several months, they first set foot on their newly purchased property, the former Gregory homestead, in 1898.

Miami was a wilderness, and those arriving on the shores of Biscayne Bay in that era were truly pioneers. According to longtime Gables resident Kathryne Ashley, author of *George E. Merrick and Coral Gables, Florida*, Richard Merrick, George's brother, stated in an interview some years later that when they went to Miami to get supplies, the panthers would run alongside the wagon if they happened to have any fresh meat with them.

Although leaving Miami to go to college, George was never long out of touch with his father, and with the elder Merrick's death in 1911, George returned to a destiny that would identify him for all time with the city he would soon create.

The early settlers would come to Miami first, and some would then move south to Coconut Grove or to the area west of the Grove, sustaining themselves through farming, fishing, and hunting, fish and game being abundant in the region at the end of the 19th and the beginning of the 20th centuries. Crops and trees grew quickly in the sunny climate (albeit punctuated by frequent rain), and while the couple making a homestead for themselves is unidentified, it is believed that the woman in front of the mango tree may be Althea Merrick. Both of these photographs are from a pioneer Coconut Grove family's album.

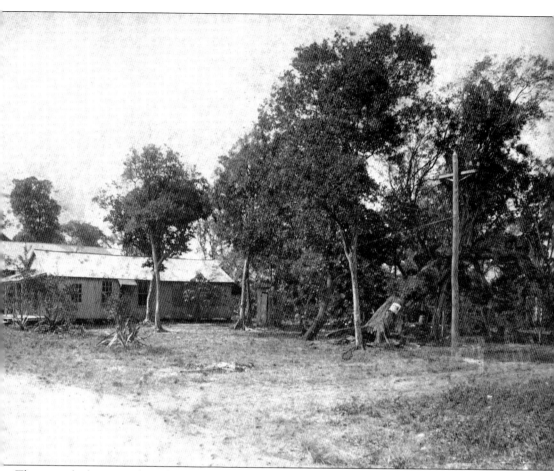

There was little reason for either the Merricks or anybody else to take pictures of the early Coral Gables Plantation property; hence any photographs reported or reputed to be from the family farm are worth their weight in gold. Marked on the back of this incredible image are the magic words, and it is believed that this photograph is one of the oldest views of what would eventually become Coral Gables, complete with requisite outhouse (under the trees, at the rear and to the right of the long building on the left).

Early dwellings south of the Miami River were made and built to the best of the owner's ability. This couple, dressed proudly in their Sunday best with their son looking boyishly uncomfortable in his Lord Fauntleroy collar, is standing in front of the first shingle-roofed house built in the area after Miami was incorporated in 1896. The other couple, with their three children and a rooster in the left background, although apparently living in a palm-frond roofed house, do not appear too uncomfortable.

Two

A City is Born

As early as 1914, Merrick recognized the value of real estate and began developing various Miami subdivisions, including Grapeland, Goulds, and Riverside Heights, which remain today. By 1920, he had built at least 10 subdivisions.

With the beautiful Eunice Peacock at his side, George began to expand his farm, and by 1918, the Merricks' holdings totaled 1,200 acres. George developed the largest and most prosperous fruit and vegetable plantation in South Florida. "In 1918," the *Miami Herald* wrote, "Coral Gables Plantation had shipped more than 107 carloads of grapefruit, oranges and vegetables." George employed 30 to 70 men at various times and operated three motor trucks.

Following World War I, a building boom began, and building permits totaling $1 million in 1918 tripled by the following year. By 1920, George had purchased enough land to begin planning a utopian community with a dream of bringing the splendor, style, and grace of the Mediterranean to his extensive acreage, complete with a magnificent hotel, a great seat of higher education, a Venetian pool, a beautiful city hall, and accompanying country clubs, golf courses, parks, fountains, majestic streets, and 40 miles of waterways.

To begin work, Merrick needed exceptional people. He assembled a world-class team that included his uncle Denman Fink as artist; his cousin H. George Fink as his architect (later joined by the great and talented Phineas Paist); writers Frank Button (who also served as landscape architect), Rex Beach, and the indomitable Marjory Stoneman Douglas; William Jennings Bryan as his spokesman; Edward E. "Doc" Dammers as his sales manager; Telfair Knight and F. W. Webster as his corporate executives; and John McEntee Bowman as the builder of the magnificent Biltmore Hotel.

Studying maps of Spanish towns and cities, George and Eunice painstakingly selected each street name, often based on their reading of Spanish history texts by Washington Irving, who once served as U. S. ambassador to Spain.

In 1921, the first lot in what would become Coral Gables was sold, and within four years, George Merrick had invested $100 million in the city's infrastructure. Through the genius and sales acumen of "Doc" Dammers—who, on one particular day, sold $1.4 million worth of property—and the stunningly beautiful advertising, coupled with a level of promotion and publicity unseen and unheard of up until that time, Coral Gables was soon to achieve national renown. The rest, as they say, is history.

Whether by two wheels or four, civilization slowly but surely began making inroads into the hinterlands of Dade County, and whether utilizing the motorized bike or the early touring sedan, people were interested in seeing more of the paradise that was South Florida. In the early years, only one road—Twentieth Street, later Southwest Eighth Street—actually went into what would become Coral Gables. The South Dixie Highway was several years in the future. The Florida East Coast Railway stopped its passenger trains at Coconut Grove and in Larkins (South Miami), north and south respectively of what would become the Gables, but there then being no Coral Gables, there was no need for a depot.

Merrick knew almost from the inception of the grand project that a high-grade hotel would be necessary to house visitors and prospective buyers, and though Coral Gables would have several, including the later Biltmore, the Coral Gables Inn would be, for a good few years, the hotel of choice. This brochure is one of the earliest known—and is possibly the first—of the promotionals for the hotel.

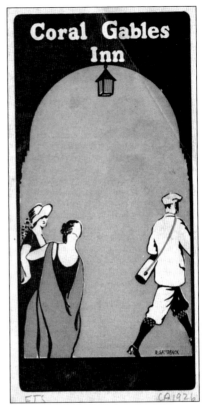

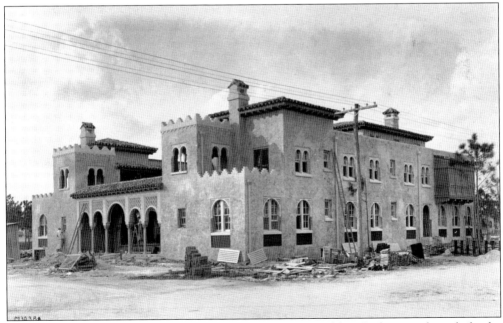

The inn is still under construction in this very rare original Fishbaugh photograph made for the corporation in the early 1920s. Located at 303 Majorca Avenue, Coral Gables Inn was the first of the Gables hotels to be built.

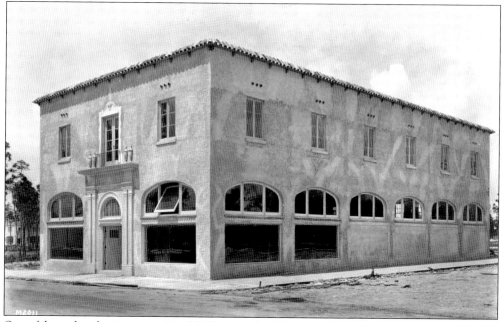

One of the earliest businesses in Coral Gables was the Yelvington and Osborne Furniture Company. The street signs are not yet in, and there is no information on the photograph except the name of the company, but with the door open and the unfinished appearance of both the building and the street, the photograph is both rare and early.

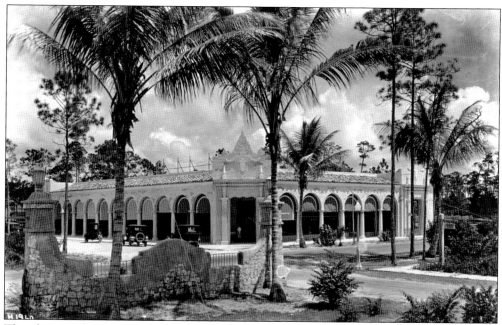

This photograph was taken standing on Alhambra Circle looking at the Arcade Stores, for years a favored shopping spot for well-to-do Gablesites.

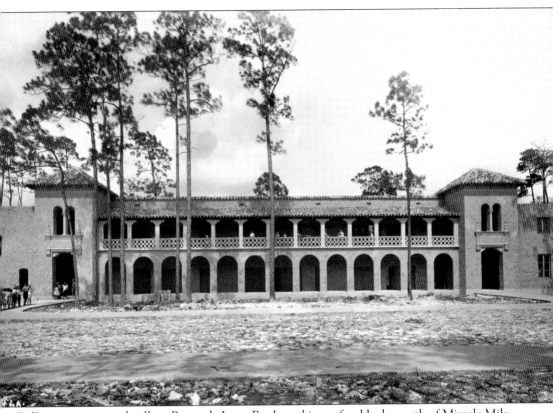

Still in operation and still on Ponce de Leon Boulevard just a few blocks north of Miracle Mile, at 105 Minorca Avenue, Coral Gables Elementary School was and is the place where generations of young people began their education. It is believed that this Fishbaugh photograph was taken during the school's first year.

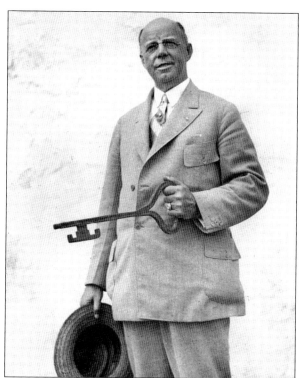

Seen holding the key to the city, Edward E. "Doc" Dammers became the first mayor. Dammers worked for Miami Beach's founder, Carl Fisher, as a salesman prior to being lured away to become George Merrick's sales director. He would later partner with Harry Burnes as Dammers and Burnes, sales agents for Coral Gables. Dammers was of the Jewish faith, and that, perhaps, was part of the reason that Merrick never had religious restrictions on the sale of Coral Gables properties. (Courtesy City of Coral Gables Historical Resources Department.)

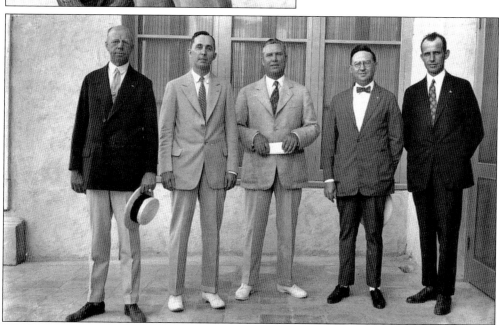

Coral Gables officially became a city on May 1, 1925. Two days earlier, the first city commission posed proudly together. From left to right are Mayor Dammers; Telfair Knight, vice president and general manager of the Coral Gables Corporation; Merrick; F. W. Webster, vice president of the corporation; and J. F. Baldwin, corporation treasurer. Merrick, of course, was the founder, but it took each of these men doing his part to bring Merrick the success he so richly deserved. (Courtesy City of Coral Gables Historical Resources Department.)

Coral Gables' first chief of police and director of public safety was M. P. Lehman, shown here on the bench in front of police headquarters. A thorough search of the historic records and documents of the department by the fine members of the current Gables Police Department's Public Information Office did not yield the chief's first name, and it does not appear on any of the photographs in the department's or the city's possession. (Courtesy City of Coral Gables Historical Resources Department.)

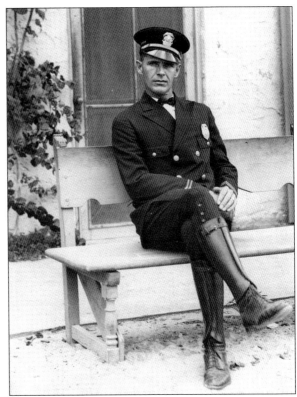

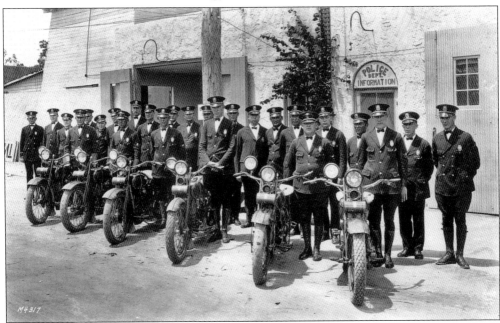

The city's entire 25-man police department poses with Chief Lehman in front of the headquarters building on August 12, 1926, the city only a little over 15 months old at the time and already equipped with six motorcycles. The chief is the tall man standing behind the third motorcycle from the right. (Courtesy City of Coral Gables Historical Resources Department.)

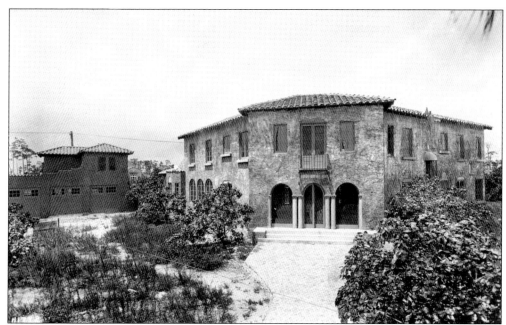

The building of apartment houses in the city was a matter of concern to George Merrick, the Finks, and, later, Phineas Paist, as each building had to conform to rigorous rules regarding construction materials, placement on the property, setback rules, and design. Although there is no information on the back of this Fishbaugh photograph, H. George Fink's name is prominent. The doors, windows, and garage were completed, at least on the exterior, but the driveway is still unfinished in this c. 1923–1924 photograph.

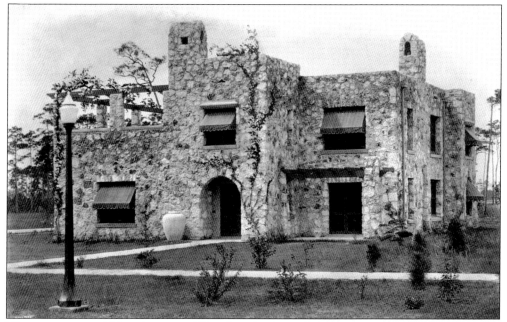

The apartments of Mrs. Ernest at Alhambra Circle and North Greenway Drive are, in this photograph, surrounded only by empty land, although the original streetlight is in place, and Mrs. Ernest has placed a beautiful, large urn at the front door.

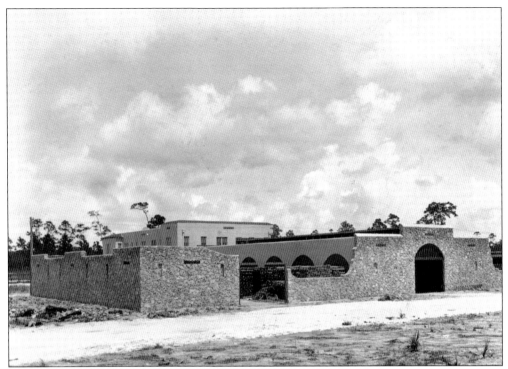

Commercial buildings were held to the same high level of appearance as the homes and apartments—Merrick would have it no other way. This is the Renuart Lumber Company, which was, according to several people in Coral Gables, on Ponce de Leon Boulevard.

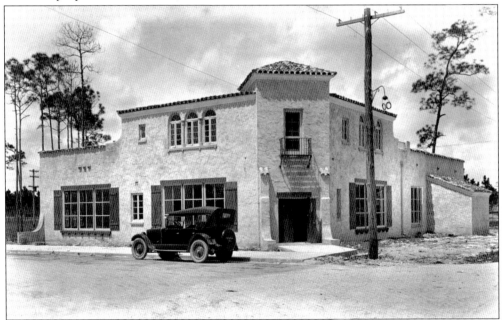

This is the printing office of the corporation at the corner of Salzedo and Alcazar. The building has survived and is still there today. As one can see, the road is unpaved, the grounds are still without planting, and although the electric poles are in place, the building is still unoccupied.

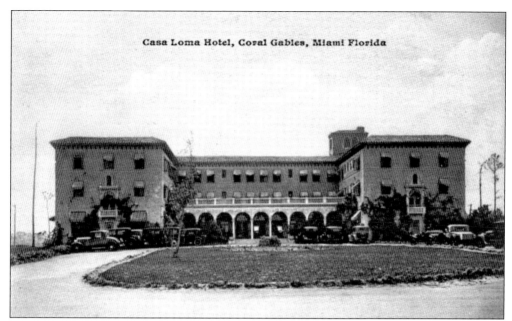

Casa Loma Hotel, Coral Gables, Miami Florida

Two of the Gables' favored hotels were the Casa Loma and the Cla Reina. The Casa featured a large open terrace between its two wings, and the building was essentially in the shape of a U. Shown shortly after opening, the jalopies and roadsters are very much in evidence in front of the hotel.

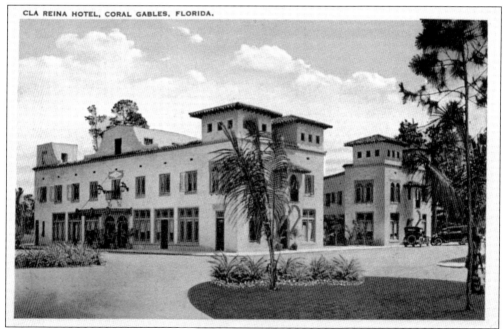

CLA REINA HOTEL, CORAL GABLES, FLORIDA.

The Cla Reina featured large, airy, third-floor apartments, and guests seeking them made reservations well in advance. Most of the guests in the Gables hotels were there for much of the social season, while Miami Beach's guests were there for "resorting" and generally shorter stays. Downtown Miami was where the business people stayed: for some years at the Henry Flagler–built Royal Palm Hotel and later at the several Biscayne Boulevard hotels built in 1924 and 1925.

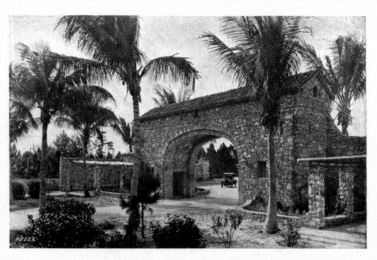

America's Finest Suburb

 DOWN towards the southernmost edge of Florida, in Miami of famed climate, winter bathing, of warmth and sunshine and brilliant flowers at this time when most of the country is blanketed in snow and ice, lies Coral Gables—America's finest suburb. Its claims to this honor rest neither on vain boast nor ambitious boost, but on the merit of magnificent accomplishments already achieved in the most broadly conceived town-planning project attempted in this country.

For more than two years Coral Gables has been in the process of building, and the elaborate development program adopted calls for a continuation of this great work for at least three years to come. More than $5,000,000 have been already expended in the work, and fully $20,000,000 will be spent before it is completed.

Two magnificent entrances have been completed that are worthy of rank among the grandest architectural gateways of Old Spain, and a third is now under construction; eight noble plazas have been built; fifty miles of streets and parked boulevards; a White Way that extends now for eighteen miles, with intersectional street electric lighting throughout all sections; more than 400 Spanish homes of distinctive beauty with tiled roofs, spacious lawns and every comfort and convenience. One golf course completed and another under construction; tennis courts, playgrounds, bridal paths and Venetian pools for outdoor bathing, add to the joy of living at Coral Gables. The Business Section, apart from the residential areas, but developed just as beautifully, contains the hotel, school, several retail stores and industrial plants. Against a background of comparatively high, elevated ground, and all of the natural beauty of Caribbean pine, rise the lofty coconut and royal palms of Coral Gables, the masterful artistry of Spanish gateways and plazas, and here is to be found a suburb of compelling beauty, with all of the allurement of Florida at its best. It is a spot which invites the interest and study of travelers, which beckons appealingly to those who seek the ideal winter home in Florida, and which offers rare opportunity for profitable investment. Write today for descriptive booklet of Coral Gables, Miami and other interesting places in Southern Florida.

CORAL GABLES

America's Finest Suburb
Miami, Florida

GEORGE E. MERRICK, Owner and Developer.
DAMMERS & BURNES, General Sales Agents.

Executive Offices: 158 East Flagler St., Miami, Fla.
Florida Offices: Jacksonville, West Palm Beach, Daytona, Orlando, Tampa, St. Petersburg, Sanford, Lakeland, Deland, Eustis.

Merrick's advertising for Coral Gables began very early in the 1920s. This advertisement appeared on the inside front cover of *Travel* magazine's February 1924 issue and features the Granada entrance. Merrick was so enamored of this view that he used it for one of the "gold" postcards the corporation published as a series of views of the city. The Gables Corporation sales offices would shortly move to East Flagler Street in downtown Miami, and, interestingly enough, no Coral Gables office is noted in the advertisement. Within another year, sales offices would be located throughout the Northeast and Midwest.

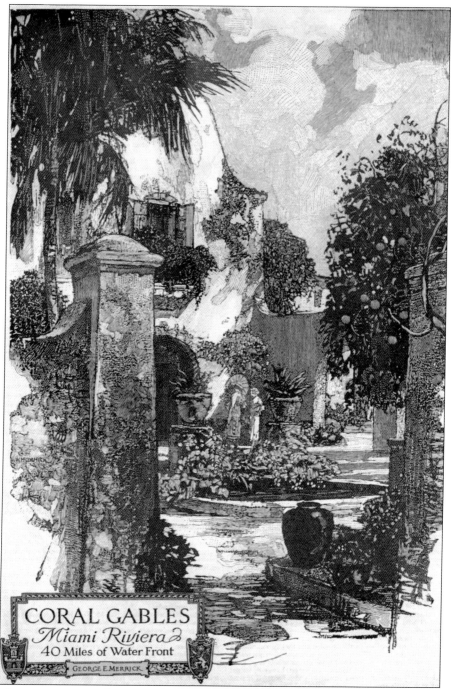

The advertisements ran the gamut from gloriously beautiful full color to more subdued views in earth tones, suggesting a more peaceful, placid existence, especially as shown here, with the beautiful garden and the fish pond, the strategically placed urns, the palm tree on the left, the flowers and trees and, perhaps most importantly, the orange tree in full bloom on the right. A true artist's masterpiece, this advertisement was created by Denman Fink and appeared in *The Literary Digest* on February 27, 1926.

Will you take the priceless gift of-LIFE?

RONZED, ERECT old men. Women delighting in new cream-and-rose complexions. Round and brown children. Handsome, full-figured youngsters. These are evidences of the extraordinary vitality and superb health that come from living under the tropical skies of Coral Gables. And when you see these people you will believe, as we do, *that the only American tropics will add years to your life, and will add new pleasures and delights to each year.*

CORAL GABLES, Miami's most beautiful suburban city, is planned to give space and air, sun and breeze to every inhabitant. The magnificently wide avenues and plazas open the city to the cool, spicy trade-winds. The tropical planting and the forests temper, but never obstruct, the life-giving sun. The white sand beaches offer miles of sea-bathing that is as safe and pleasant as anywhere in the world. All that you seek in recreation is at your door. The peace and quiet, the freedom from noise and crowds, take away the lines from strained faces. Troubles have a way of disappearing at Coral Gables. Life becomes active, colorful and healthful.

Property Values are Rising. Investments are Paying Remarkable Dividends

Under the wonderful city plan and the careful restrictions, property values tend to increase steadily and surely.

Home-builders are even now watching their property rise in value month by month. Every buyer of property in Coral Gables literally cannot help sharing in the profits that attend every step in the development of the city plan, and in the prosperity that is so rapidly transforming Miami and its environs.

The Coupon Will Bring You Rex Beach's Dramatic Story—Free

REX BEACH has written a fascinating tale about the miracle of Coral Gables. It not only tells the complete story of this city, but also contains the facts and figures that prove its success. We will also tell you about the special trains and steamships that we run to Coral Gables at frequent intervals. If you should take one of these trips, and buy property in Coral Gables, the cost of your transportation will be refunded upon your return. But first of all—*sign and mail the coupon—now!*

Remarkable Opportunity for Investment

The 1920 census showed a growth in Miami's population of 440 per cent in ten years. Since then it has increased even more rapidly. Bank clearances today are ten times those of a year ago. Every activity feels the stimulus of this tremendous growth, and especially is it manifested in the increase of property values in the city and suburbs. In Coral Gables the value of home and business sites has increased amazingly every year for the past three years.

Yet building plots in Coral Gables may now be secured by a small initial investment. These plots are offered in a wide range of prices, which include all improvements such as streets, street lighting, electricity and water. Twenty-five per cent is required in cash, the balance will be distributed in payments over a period of three years.

The Facts About Coral Gables

Coral Gables is a city, adjoining the city of Miami itself. It is incorporated, with a commission form of government. It is highly restricted. It occupies about 10,000 acres of high, well-drained land. It is four years old. It has 150 miles of wide paved streets and boulevards. It has seven hotels completed or under construction. It has 45 miles of white-way lighting and 50 miles of intersectional street lighting. It has 6½ miles of beach frontage. Two golf courses are now completed, two more are building. A theatre, two country clubs, a military academy, public schools and the college for young women of the Sisters of Saint Joseph are now in actual use. More than one thousand homes have already been erected, another thousand now under construction. More than fifty million dollars have already been expended in development work. Additional plans call for at least twice that amount. More than one hundred million dollars worth of property has already been bought in Coral Gables.

Mr. John McEntee Bowman is now building the ten-million-dollar hotel, country club and bathing casino in Coral Gables to be known as the Miami-Biltmore Group. The Miami-Biltmore Hotel will be opened about January, 1926. Coral Gables will also contain the following buildings and improvements:

The $15,000,000 University of Miami, the $500,000 Mahi Temple of the Mystic Shrine, a $1,000,000 University High School, a $150,000 Railway Station, a Stadium, a Conservatory of Music, and other projects.

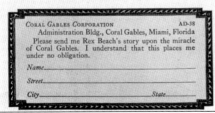

It was the early 1920s, and Merrick could do no wrong. Storm clouds were not on the horizon, and the 1926 hurricane, the storm to end all storms (at least up until that time), was not even a thought. This advertisement appealed to the ego: come to Coral Gables and be young again, come to enjoy the people, the weather, the beauty, and the Biltmore Hotel, opening about January 1926. It was an invitation to paradise.

504 licensed firms and individuals are now actively engaged in 86 lines of business in Coral Gables

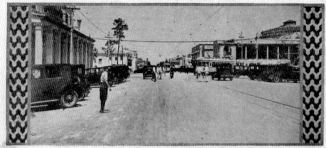

The business section of Coral Gables at the intersection of Coral Way and Ponce de Leon Boulevard. These main business streets are 100 feet wide, allowing plenty of parking space and avoiding all traffic congestion.

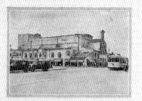

This is the Coral Gables Theatre, controlled by Famous Players-Lasky Corporation, seating 1500 people. Another theatre seats 1100, and the Coral Gables Stadium, a temporary structure soon to be rebuilt in concrete, seats 7200 people.

At your left is one of the retail stores where residents of Coral Gables do the bulk of their buying. Next door is one of the two banks established here—the new Coral Gables First National Bank.

CORAL GABLES is anchored safely in the harbor of sound and normal business. Its building and development have never halted. Its careful plans for even greater improvements are moving steadily toward completion. And best of all, the business activity that is certain indication of progress in any city is lively, profitable and increasing steadily in volume.

Today, residents of Coral Gables can build, furnish and decorate their homes without buying a single article outside their city. Their clothes, their food, their motor-cars, and literally every need of living is supplied by their own merchants. In addition to these residents and the yearly flood of winter visitors, the payrolls of more than 190 contractors —building, plumbing, electrical, roofing—as well as the payrolls of lumber companies, supply companies and small manufacturers, help to swell the volume of retail trade.

Building permits in Coral Gables during the first 8 months of 1926 totaled $11,174,317, an increase of nearly 20% over the same period in 1925. Of this total, 15½% or $1,743,000 was for business or industrial structures. . . . For business men everywhere are watching the rise of Coral Gables closely. Its business opportunities are open to *you*. Act now, while favorable locations may be secured and trade easily developed. Write to Dept. C-1 of the Chamber of Commerce of the City of Coral Gables, Florida, for full information.

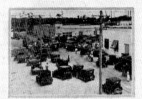

Pay-day at the Coral Gables Construction Company. The payrolls of the 190 builders and contractors in the first 8 months of 1926 released about $8,000,000 for the benefit of the merchants of Coral Gables.

The Bank of Coral Gables, which has over 3000 accounts. Capitalization $100,000, surplus $20,000, deposits September 15, 1926— $1,250,000. The Coral Gables Post Office, in the same building, delivers mail twice daily throughout Coral Gables.

City of Coral Gables

A Unit of Greater Miami, Florida

We know now that when this advertisement ran in *Colliers* magazine for the week of October 23, 1926, the great hurricane of September 17th and 18th, which wreaked such havoc and destroyed so much of Miami and Miami Beach, had already passed, and, though the advertisement was in production before the hurricane and likely had been submitted prior to that terrible disaster, the bubble had burst, and the boom was broken. While this advertisement ballyhooed the businesses that had made a home for themselves in Coral Gables, many of them would close as sales declined and the economy worsened. By 1929, Coral Gables, like the rest of the country, was in deep financial trouble.

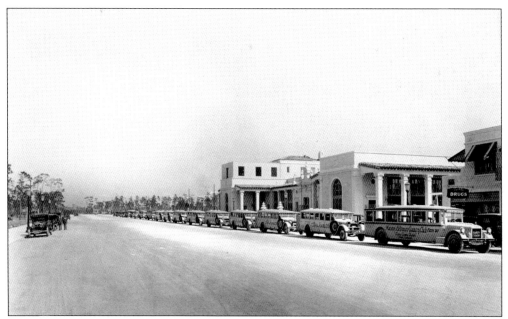

"And how did they get to Coral Gables?" The answer was simple! "We'll bring them by bus!" And bus them in they did, with Coral Gables Corporation busses being sent throughout the eastern half of the country and as far west as Kansas City. Parked on Coral Way (later Miracle Mile) in front of the original administration building, part of the fleet awaits their next trip assignments and will soon be off to distant points, bringing prospective home, business, and property buyers to the Gables. In this view, 17 Coral Gables busses are visible.

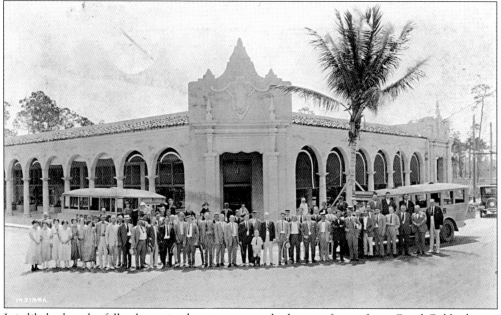

It is likely that the folks shown in the picture stretched out in front of two Coral Gables busses are a mix of prospective buyers and Merrick staffers. Though nobody is identified, we can see the words "Coral Gables" on the first panels of glass visible to the left of the entrance of the Arcade Stores, the building shown previously on page 18.

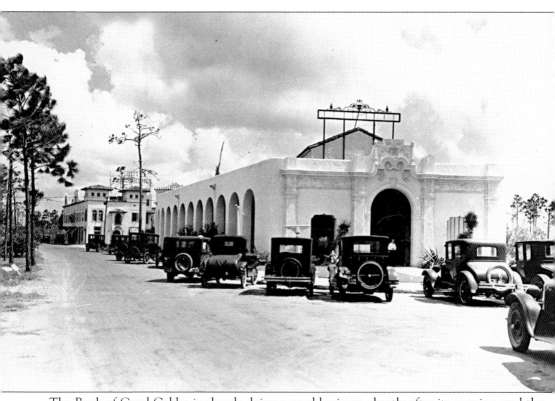

The Bank of Coral Gables is already doing a good business, shortly after its opening, and the building is so new the sign has not yet been put in place. Immediately behind the bank is the sign from the Cla Reina Hotel, shown on page 24.

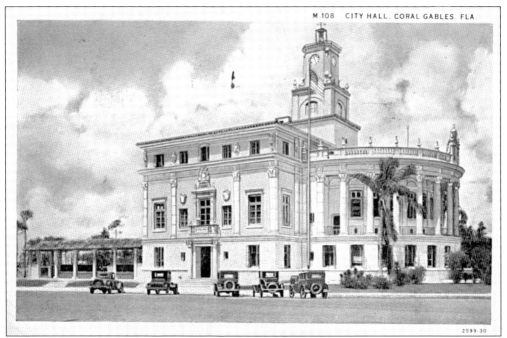

Even city hall had to be a monumental structure, pleasing to the eye and business-like at the same time. These two views show the building—which still looks very much the same today and is still Coral Gables City Hall—within just a few years of its opening. In the upper view, early-1920s vintage automobiles park at the curb, and in the lower view, the streetcar track, complete with trolley wire overhead, is clearly visible. A close examination of this photograph shows the Biltmore tower in the distant left background.

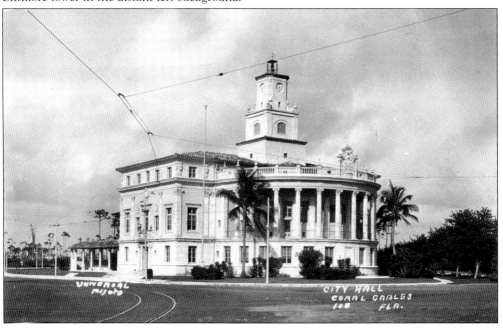

31

The huge amount of publicity that the Coral Gables Corporation generated and that Merrick received even extended to his personal financial statement. Three-and-a-half inches by nine inches, the statement opens to seven inches by nine inches and is dated December 1, 1923. As of that date, Merrick's Coral Gables assets were over $13 million and his liabilities only $3.33 million, certainly an enticing picture for any would-be investor.

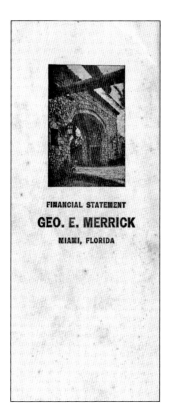

This is the cover of an early Merrick promotional, this one featuring "Mediterranean Homes in the American Tropics." Note that the banner at the bottom of each page makes reference to Coral Gables as "Miami Riviera," that there are "40 Miles of Water Front," and that it includes the obligatory appearance of Merrick's name.

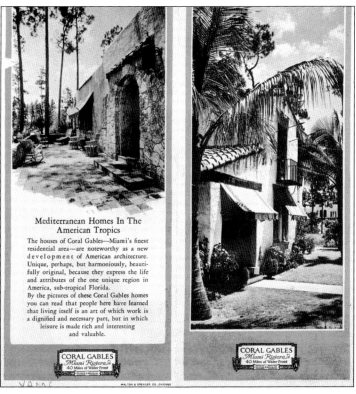

Mediterranean Homes In The American Tropics

The houses of Coral Gables—Miami's finest residential area—are noteworthy as a new development of American architecture. Unique, perhaps, but harmoniously, beautifully original, because they express the life and attributes of the one unique region in America, sub-tropical Florida.

By the pictures of these Coral Gables homes you can read that people here have learned that living itself is an art of which work is a dignified and necessary part, but in which leisure is made rich and interesting and valuable.

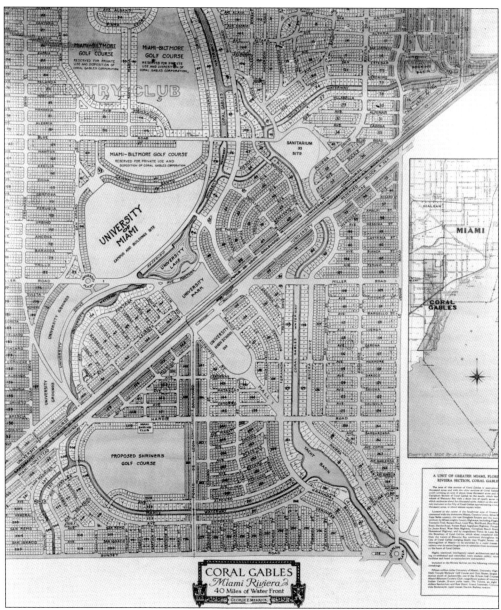

This is the map of the University section of the city, but much of what is shown in 1926 would not, following the September hurricane and subsequent downturn in the economy, come to pass. Among the entities and facilities never completed were the trolley line down Ponce de Leon Boulevard parallel to the university, the Shrine Club and Shriners Golf Course, the University High School, and a Coral Gables Florida East Coast Railway depot. Because Merrick never built the depot, passenger trains would pass through but would never have a designated Coral Gables stop, residents having to go to either Coconut Grove or Larkins (South Miami) to board the train.

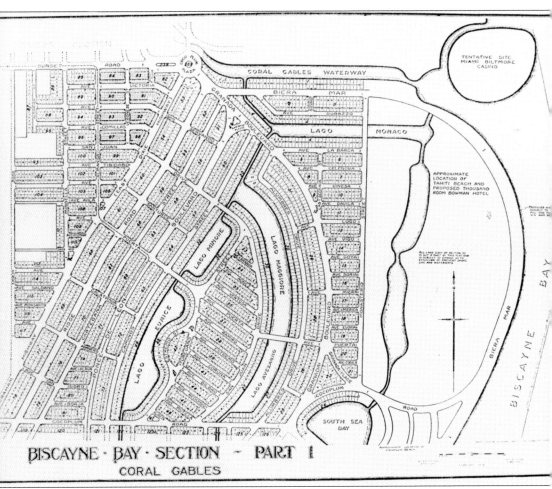

BISCAYNE · BAY · SECTION — PART I
CORAL GABLES

Merrick knew that, to be completely successful, he had to have a waterfront, and not just canals or waterways, as part of the development. This 1926 map, from the original in the author's collection, is, to quote a beloved personage, "fascinating" to any Coral Gables historian, for among the proposed but unbuilt buildings are the Miami Biltmore Casino (top right, apparently on an island) and the "Proposed Thousand Room Bowman Hotel," shown in the area scheduled to be filled in from Biscayne Bay. What makes this extremely interesting is that it is not known if this was to be the original location of the Biltmore or if this was to be another Bowman hotel.

In 1926, the corporation reprinted, in full, several articles that appeared in the *Wall Street Journal*, the *Miami Daily News*, and the Watertown (New York) *Standard* in a three-and-a-half-inch-by-nine-inch, 24-page, heavy-stock-covers booklet titled "What Wall Street Thinks of Coral Gables." Suffice it to say, it was all good! The booklet, today, is a fascinating look at what and how the media of the day were reporting regarding the Coral Gables story.

This stunning brochure, depicting the Venetian Pool on the front cover and a view of a beautiful Coral Gables waterfront home on the back, starts at 4 inches by 9 inches and opens to 12 inches by 18 inches, one side promoting "America's Foremost Waterfront Property," the other showing a full map of the state of Florida with all roads, both paved and unpaved. The brochure ballyhoos the fact that Coral Gables is "Nationally Financed/Nationally Advertised/Nationally Sold" and that it is "Rich in the Allure of the American Tropics." Given the elegant light blue and pink pastels interspersed with black and white for highlights that the brochure was printed in, it is easy to understand how and why Coral Gables was, at least until the bubble of the boom burst, an easy sell!

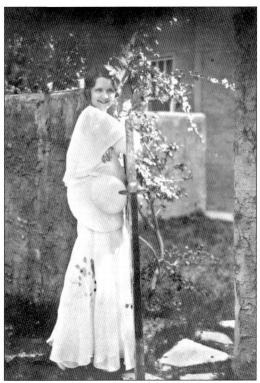

Eunice Peacock Merrick was the great love of George's life, and she was a beautiful and vivacious woman. George told her that, while he was attending to business, she would need to attend to social affairs, and she was a marvelous hostess at the innumerable events going on in the great swirl of activities that was an integral and ongoing part of Coral Gables life. Although not marked on the back of the photograph, it is believed that this is Eunice standing on the walkway behind the Merrick house at 907 Coral Way.

DC.292—The Original Coral Gables Home Made of Coral Rock with a Gabled Roof

This is the Merrick house, which today is a revered and beloved Coral Gables landmark, preserved because W. L. Philbrick, who purchased it from the estate, refused to allow it to be torn down. Philbrick was finally able to convince the city to purchase the house as a memorial to the founder, selling it to them for a nominal amount. Open to the public, it preserves the legend and legacy of George Merrick.

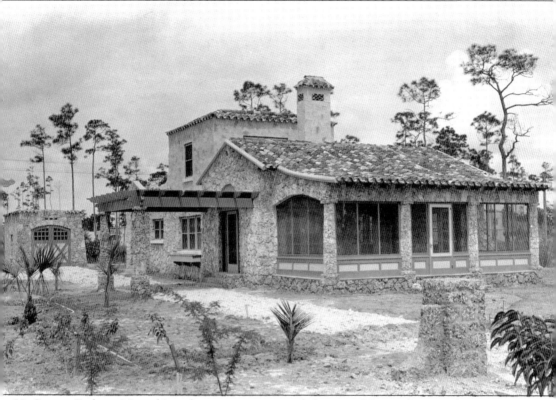

H. George Fink, as Merrick's architect, commissioned the great Miami photographer W. A. Fishbaugh to preserve on film most of the homes and buildings as they were in various phases of construction. On this and the following several pages, examples of Fink's inventive and fertile imagination are shown, and the reader will note that, unlike the assembly-line homes in too many "cookie cutter" developments, Fink and Merrick worked to insure the individuality of each property. Most of these homes still exist today, and it is likely the owners will recognize the houses as they were c. 1922–1925. The two-story, coral-rock home shown on this page is on the corner of Cordova and North Greenway Drive.

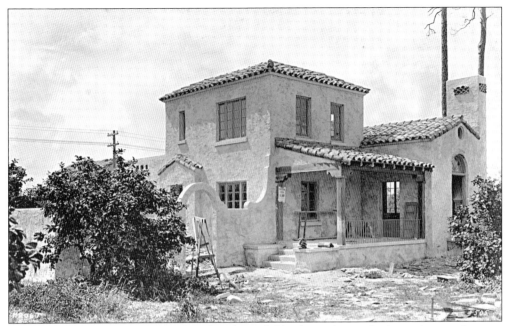

This two-story home with Spanish-style, tile-roofed back porch, was built on Asturia Avenue. Note the chimney on the right. Many South Florida houses, mild though the climate was, were built with fireplaces for "those chilly winter nights!"

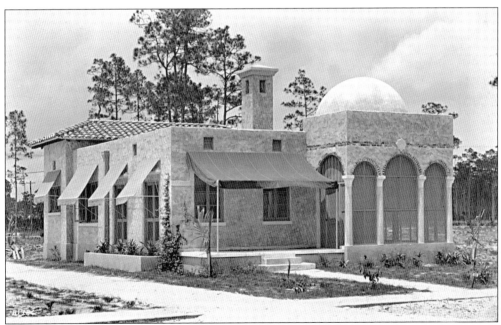

There are two exact Fishbaugh photographs of this house in the author's collection, but each of the two has a different legal description on the back; hence, although we were unsure of which street it is on, the Avenue Obispo booklet of homes on that street (see page 55) answered the question. In any case, the dome is rather unique to Coral Gables—and Fink's—construction.

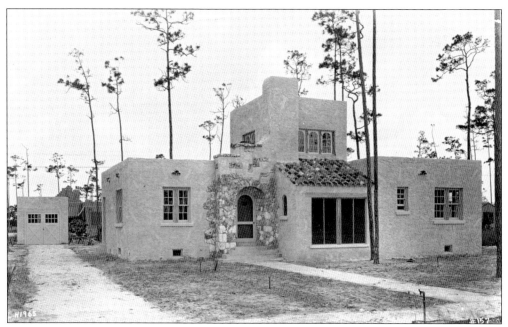

It appears that one- and two-story homes were equally distributed throughout the city. This two-story beauty, with separated garage, is on Alhambra.

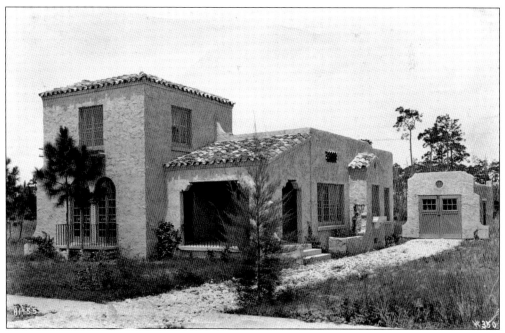

Another beautiful example of two-story architecture, this home, also with a freestanding garage, is on Navarre.

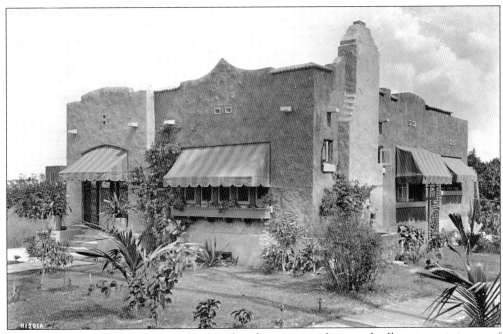

Gracing the corner of Valencia and Palos, this charming single-story dwelling is reminiscent of the American Southwest.

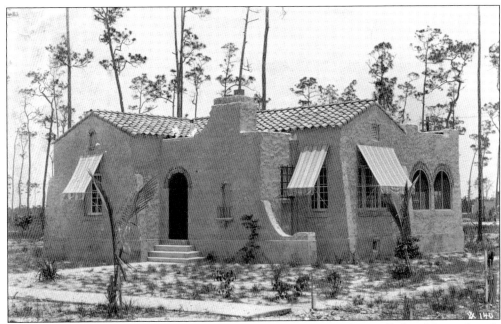

Compact and inviting, this delightful edifice, with awnings already installed and Spanish-style faux porch to right of the front door, is at the corner of Columbus and Obispo.

In selling Coral Gables, Merrick took a "macro" approach and overlooked nothing in terms of promotion. This booklet, for example, titled *Coral Gables Homes*, is five-and-a-quarter inches by eight-and-three-quarter inches, with 32 pages of exterior drawings of homes—one to a page— the owner's name if the house was sold, the architect's name below that, and, below that, the layout plan. An incredible booklet, each page, in effect, shows the house both inside and out.

Another great "homes" booklet, this one is 8 inches by 11 inches horizontal with 32 pages. However unlike the other *Coral Gables Homes* booklet shown on this page, this one has only photographs of homes, one or two to a page, with the owner's name featured. There are no plans for the houses in this booklet.

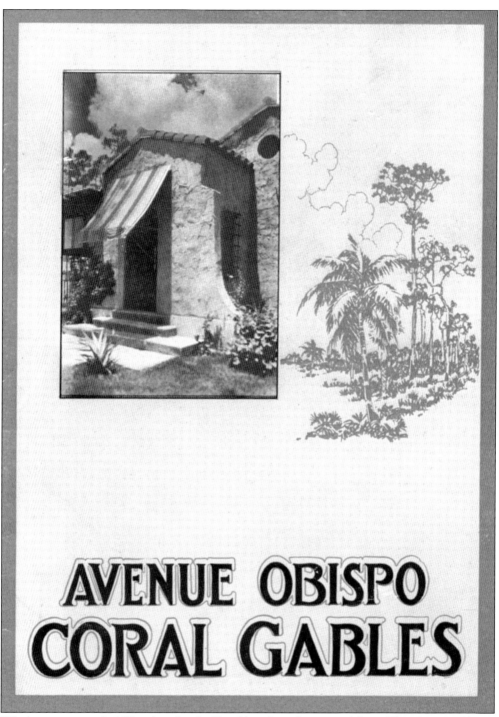

AVENUE OBISPO
CORAL GABLES

Whole streets were "sold," with individual booklets done for some of them. This Avenue Obispo book measures five-and-a-half inches by seven-and-a-half inches and has 16 pages, including a title page with one photograph on it, two pages of text, and 12 pages of photographs of the homes on Avenue Obispo, including the home with the dome noted on page 38.

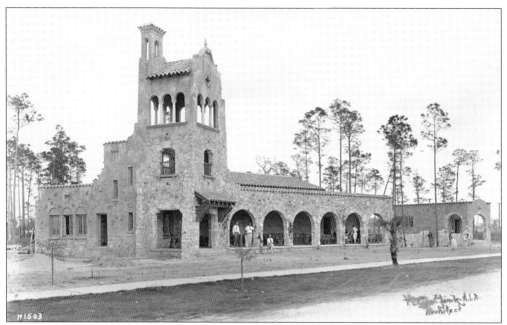

Merrick understood that recreation was a major draw, and in addition to Venetian pools and the Biltmore and its pool and golf course, several private initiatives were launched to build Riviera Country Club, the Coliseum, and Tahiti Beach. Merrick's pride and joy was the city's own Coral Gables Country Club, and it became a focal point for Gables residents, as they were welcome there to enjoy dining, dancing, and golf in a warm and congenial atmosphere. In this photograph, the original front of the club is visible, and, although somewhat smeared, H. George Fink's signature is at lower right.

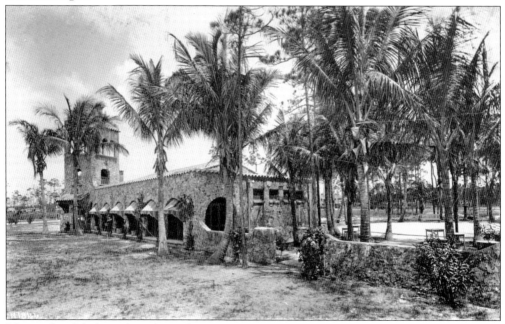

This is the club from the other side. Notice the architectural style as well as the Spanish tile covering all roof surfaces.

Coral Gables Bulletin

Published by GEO. E. MERRICK
Owner and Developer of Coral Gables

AUGUST 1, 1923

Vol. 1. No. 2

A NEW AND GREATER ERA OF DEVELOPMENT FOR CORAL GABLES

300 Acres Adjoining Granada Boulevard Adds Many New and Interesting Features

George E. Merrick has just completed a big deal in land adjoining Coral Gables, which gives a new impetus to the summer development work and is of large significance in the future of Miami's Master Suburb. This addition extends the boundary lines of Coral Gables on the north all the way to Tamiami Trail, and from Red Road on the west to a point one quarter of a mile east of Granada Boulevard.

Not the least significant feature of this immense addition of land will be the extension of Columbus Boulevard and Madrid, Ferdinand and other prominent streets all the way to S. W. Eighth street (Tamiami Trail).

The new addition also insures the extension of the Country Club Prado, mentioned in the last number of the Bulletin, all the way from Bird Road to S. W. Eighth street. This splendid two-mile boulevard, two hundred feet wide, with a parkway in the center one hundred feet wide for its entire length, will be unequaled in beauty in this country.

A new gateway will be erected at the junction of the Country Club Prado and S. W. Eighth street, facing on a beautiful plaza built in distinctive Spanish design and beautified by elaborate planting of the finest of tropical shrubs, trees and plants. From S. W. Eighth street the prado swings south past the present Coral Gables golf course, through Coral Way and the new eighteen-hole golf course, now under construction, to Bird Road. The notable feature of this splendid boulevard is, that it will begin and end with two of the most important highways in Dade County.

The work of building the Country Club Prado has already been carried forward to a considerable extent, and that of preparing the newly acquired ground has already begun. It is not a difficult matter to visualize the prado a year or two hence, when imposing residences, fine tropical trees, and flowering shrubs will be found on its entire two-mile length, and make it not only the pride of Coral Gables but also the finest boulevard in the South.

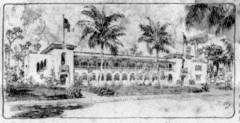

THE NEW CORAL GABLES GRAMMAR SCHOOL, RICHARD KEIHNEL, ARCHITECT

CLUBHOUSE ADDITION STARTED LAST WEEK

The Markley Construction Co. Begin Work that will Increase the Building to Double Present Size

Ground was broken last week on the big addition to be made to the Coral Gables clubhouse, the completion of which assures the largest structure of its kind in the Miami district.

The new addition will bring the building to a length of 126 feet, the greatest width of which will be 71 feet. In this addition are included a dining room 41 by 22 feet, with a dining porch and dining terrace adjoining. On the main floor there will also be two extra club rooms, one of which will be 24 by 22 feet and one 31 by 20 feet. The kitchen adjoining the dining room will be 30 by 40 feet. A servants' dormitory is also included on the main floor.

The second floor will feature 10 guest rooms all equipped with private baths. A roof garden and palm garden are included on the second floor, and an extensive loggia will be built on this floor across the entire side of the building on North Greenway drive.

The dance garden in the rear of the clubhouse, which has been a very popular feature ever since its opening, will also be added to, and a second floor of terrazza marble will be built with an orchestra stand between the two floors.

The guest rooms on the second floor of the new clubhouse are an innovation in golf clubhouses around Miami, but are among the best features of the large clubs of the north. They will undoubtedly add much to the popularity of the club with the winter visitors next season.

TWO NEW HOMES ON CORAL WAY

Mr. H. Jerome Carty, head of the Guarantee Title and Mortgage Company of Miami, is building a fine large home on Coral Way just west of Columbus Plaza. It is an attractive house of stucco, coral rock and Spanish tile with eight rooms, porte cochere and loggia, and a two-story garage for two cars and servants' quarters. House to cost about $25,000.

J. W. Ricketts, general superintendent at Coral Gables, is erecting another fine Coral Way home just west of Mr. Carty's new house. This is also of stucco with tile roof, and is finely set in the grapefruit groves that have been a beautiful feature of Coral Way for many years.

Addison H. Hazeltine is having plans and specifications prepared for extensive improvements to his home on Coral Way, which will completely remodel the home, finish it in stucco and coral, and add four bedrooms on the second floor. The work will be done at once at an estimated cost of $8,000. Worth St. Clair, of Coral Way, will on his return from Baltimore, undertake the work of changing over his home next to the Hazeltine residence.

The Montgomery home, situated for many years at the junction of Coral Way and Red Road, has been sold to J. W. Miller and removed by him from the premises. Its removal was made necessary by the building of the new Country Club Prado and the new entrance at this point.

WORK IS RAPIDLY PUSHED ON CORAL GABLES SCHOOL

First Unit of a Representative Educational Group to be Completed Sept. 1st.

Markley Construction Co., are well under way with the construction work on the new Coral Gables public school, the first unit of a fine educational group of buildings which in the very near future will embrace everything from a kindergarten to high school grades.

The building now under construction comprises six class rooms besides the principal's office, teachers' room, girl's rest room and four toilets.

Architect Richard Kiehnel, of the firm of Kiehnel & Elliott, designed the structure, which is a fine example of the best Spanish architecture. Its characteristic feature is a spacious colonnade across the front on the first floor, with loggia on second floor of the same proportions. The school will be of cement, tile and stucco with decorative features in the form of faced stone doorways and superimposed balconies. The roof will be entirely of Spanish tile.

The educational group will be located in block 16 of section "L", and the entire block will be set aside for this purpose. The building will face on Alameda street, the new 100-foot boulevard, which will be one of the finest throughout the business section.

The building now under construction will be completed by September 1st and will be for the grammar grades only. It was Mr. Merrick's earnest desire to build the entire educational group this season, but the needs of the county in other sections were too great to permit of this so that the commissioners would only consent to the erection of the grammar school building at this time. The construction of this is financed by Mr. Merrick, until such time as the county is in a position to take over the building and to give to Coral Gables the entire educational group required for an adequate school system in this fast growing suburb.

Dell E. Merrill has completed the work of excavation of the big swimming pool and is now finishing off the interior of the pool with cement.

TWO VIEWS OF THE NEW DANCE GARDEN IN THE REAR OF THE CORAL GABLES COUNTRY CLUB, SHOWING THE EXTENSIVE PLANTING OF COCONUT PALMS, WHICH HAS BEEN CARRIED ON FOR THE LAST SIX MONTHS.

The *Coral Gables Bulletin* was the somewhat regular publication of the corporation, and here, in Volume 1, Number 2, dated August 1, 1923, major additions are being made to the club, further enhancing both it and the city's desirability.

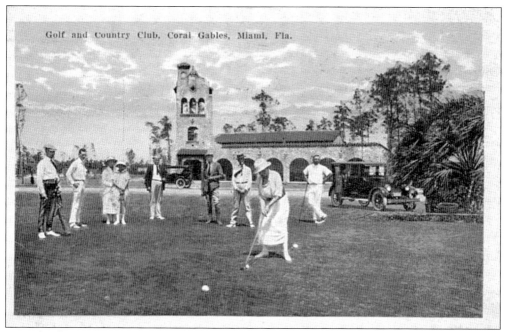

As with all country clubs, golf, even then, was the "main draw," and here, in this c. 1922–1923 view, a group of duffers and accompanying kibitzers play the game.

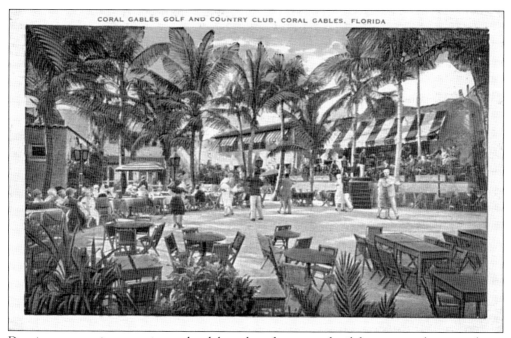

Dancing was a major attraction at the club, and tea dances, cocktail dansants, and evening dance parties made the club a rendezvous for innumerable Gables visitors and residents of all ages.

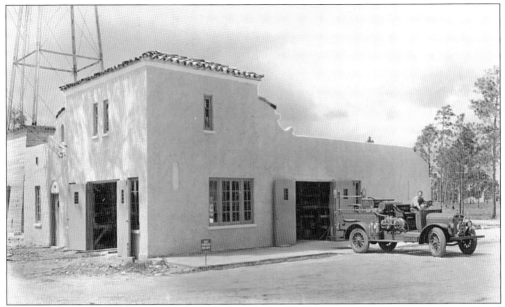

A city needs fire as well as police protection, and although the fire department had its own chief, it was under the jurisdiction of Police Chief M. P. Lehman, who was also public safety director. This very rare photograph shows the just-opened fire station, complete with roof-top water tower and tank on the adjacent building, second-floor facilities for the firefighters, and the brand-new, just-purchased pumper truck.

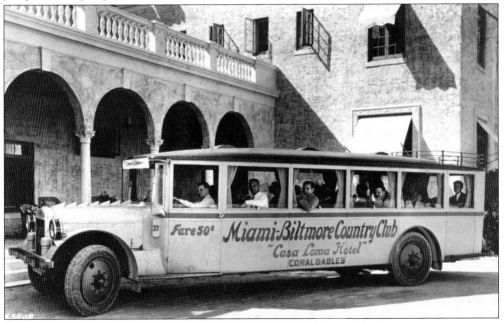

While the corporation probably had as many as 40 inter-city busses to bring prospective property buyers to Coral Gables and return them to their home cities, they also had a large number that shuttled between various points within the city. Here, at the Casa Loma Hotel, open-windowed bus number 37 awaits its last few passengers before departing for the Miami Biltmore Country Club and the adjoining Granada Golf Course.

Venetian Casino

 CORAL GABLES

As with so many other areas and parts of the city, Merrick published this rare and today highly collectible booklet promoting the Venetian Casino. The word "casino" did not, in those days, refer to gaming, but, rather, to a place where one could rent a locker, rent a bathing suit, purchase refreshments, and lounge poolside or enjoy the aquatics. There are few Gables children (or adults!) who have not, since the day it opened, enjoyed swimming, diving, and meeting others at the Venetian Pool, as it is known today. The practice pool of Coral Gables High School, the Venetian Pool today remains one of the city's best-known and best-loved attractions, and, it should be noted, the Merrick home at 907 Coral Way was built with rock quarried from this site.

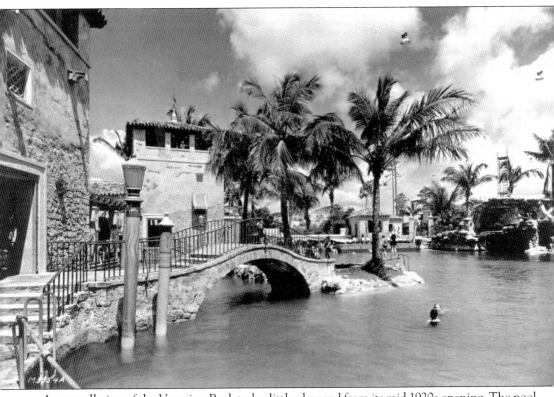

An overall view of the Venetian Pool, today little changed from its mid-1920s opening. The pool and casino have been a favorite haunt of Gables residents and visitors for decades.

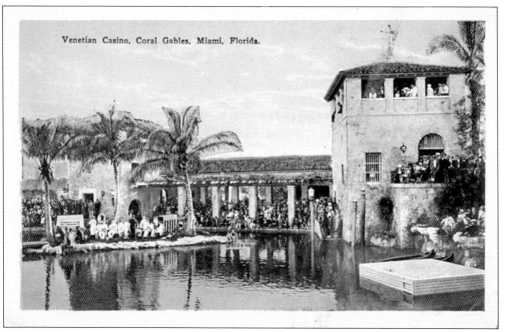

The Venetian Pool (Casino) opened in 1924; opening day is commemorated in this view. Though difficult to see, there is a band at left center, and the dignitaries are behind them. The public is aligned along the walkways, center, and the elevated areas at right.

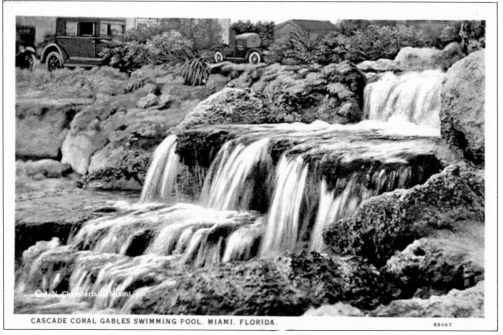

A major attraction of the pool was the cascade or rapids that so many enjoyed. Fed by fresh water, children of all ages would be invigorated by the cooling flow.

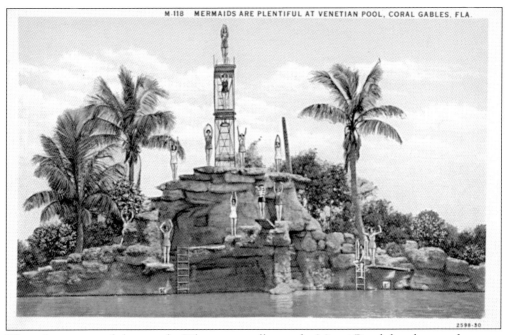

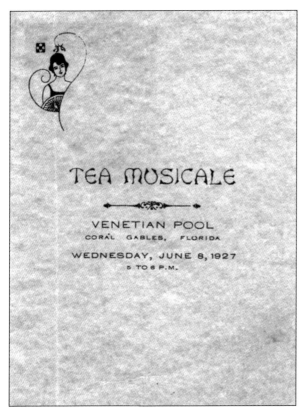

Water shows to equal those at the Biltmore as well as at the Miami Beach hotels were, for years, held at the pool, and in this view, a plethora of mermaids are seen on each diving level.

TEA MUSICALE

VENETIAN POOL
CORAL GABLES, FLORIDA

WEDNESDAY, JUNE 8, 1927
5 TO 6 P.M.

The pool was, immediately upon opening, a great gathering place for Gables residents and visitors and for people coming from all over Greater Miami. To bring people to the Gables, various events besides the water shows were held on a regular basis, and on Wednesday, June 8, 1925, a tea musicale featuring professional dance, vocal, and violin solos and dance groups was held to honor the visiting ladies of the Florida Pharmaceutical Convention.

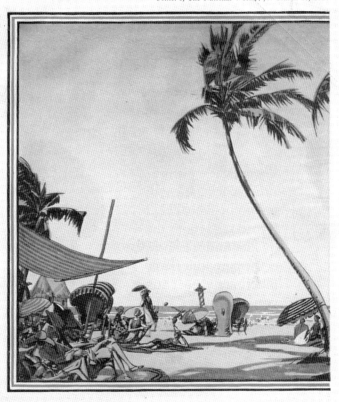

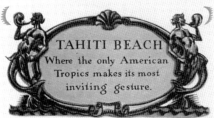

TAHITI BEACH
Where the only American
Tropics makes its most
inviting gesture.

Long, lazy rollers, crested with dazzling white, glittering like sapphires as they break. A sky deeply, brilliantly, incredibly blue. Golden sunlight that floods every living thing with energy and vitality for twelve hours each day. And along the white sands, dotted with blazing umbrellas and vari-colored bathing machines, a regal array of coconut palms marches down this coast of Coral Gables—Tahiti Beach.

Perfect roads curve along the vivid sea. Skimming hydroplanes and roaring seasleds tempt the sportsman. And everywhere, at all seasons, the kind of people you like to meet—distinguished men and women from every corner of both the Americas.

Tahiti Beach is destined to take its place with Deauville and The Lido as one of the great watering places of the world. Yet it is but one of the many advantages that focus the eyes of the world on Coral Gables. A glorious climate is one. Life-giving sunshine the year round is one. Accessibility is another, for Coral Gables is within forty hours of seven-eighths of our population. Outdoor sports claim their thousands of devotees, eager for golf, riding, tennis and other sports that enliven every day, winter or summer. The evenings are gay and charming with dances,

Not to be outdone by the island across the bay, Merrick purchased bayside property and opened a south-seas paradise aptly named Tahiti Beach. Although condos have been built on the property, the memory of those glorious years remains strong with untold numbers of Gables residents and visitors. As early as March 27, 1926, the beauty and desirability of Tahiti Beach was being advertised throughout the country in national magazine advertisements (this one was in *Collier's*).

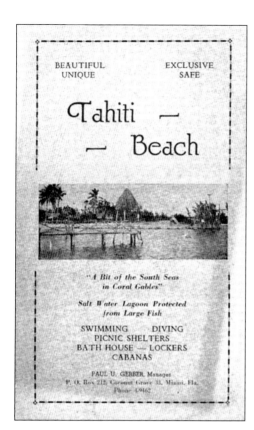

This is the front of an early Tahiti Beach advertising card featuring rates for usage on the back. The front extols the virtues of the attraction.

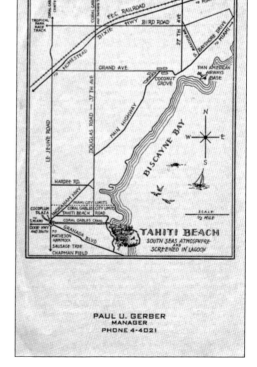

The back of a different Tahiti Beach piece, which is actually a four-page brochure, presents a map showing the exact location of the attraction and how it could be reached.

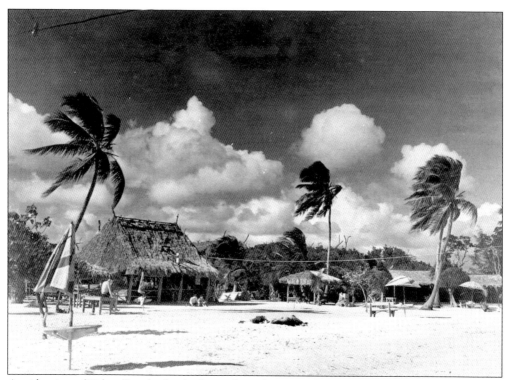

A wide view of Tahiti Beach clearly shows the palm trees, the tiki huts, and the beautiful broad beach, which many preferred to the sands of Miami Beach.

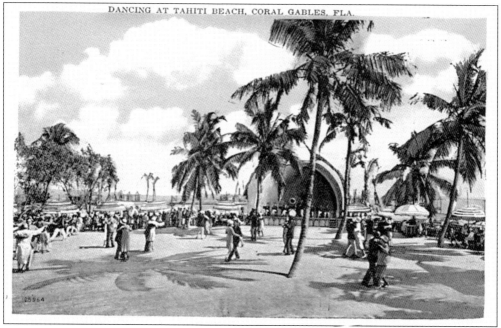

DANCING AT TAHITI BEACH, CORAL GABLES, FLA.

As with the Venetian Pool, the country clubs, and the Biltmore Hotel, regular dances were a Tahiti Beach treat, and in this fine view, the band shell is complete with a big band playing the favorites of the day.

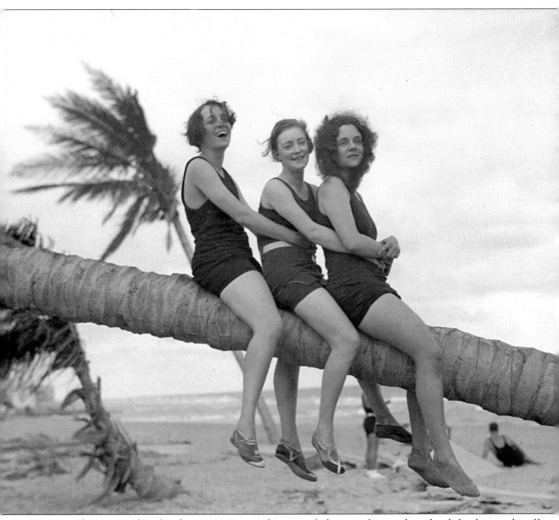

Merrick was no slouch when it came to the use of cheesecake, and, indeed, he learned well from Miami Beach's Steve Hannagan and Carl Fisher, as they used the allure of beautiful girls in then-somewhat-daring bathing suits to full advantage. Here three lovelies of the era pose on a coconut tree trunk, likely bent by the 1926 hurricane but showing that all was returned to normal in Coral Gables following the storm. This January 1927 photograph was shot by the great Miami lensman G. W. Romer.

Coral Gables

America's Finest Suburb

Miami, Florida

An Interpretation By
Marjory Stoneman Douglas

Publicity was endless, and no expense was spared to bring in top-level national names to promote the soon-to-be city. From Rex Beach to William Jennings Bryan to his daughter, Ruth Bryan Owens (a member of Congress from Florida), to Marjory Stoneman Douglas (famous later for her book *River of Grass*, which is credited with saving the Florida Everglades, and whose father was an early owner of the *Miami Herald*), the Coral Gables executives made certain that the entire nation would take note of the beautiful community which was attracting attention in every corner of the country. Douglas's major contribution to the success of Coral Gables was this beautiful book, mostly prose but with some photographs, in which she convincingly draws the reader into the web of joyous delight that he or she would attain as soon as a purchase of Coral Gables property was made.

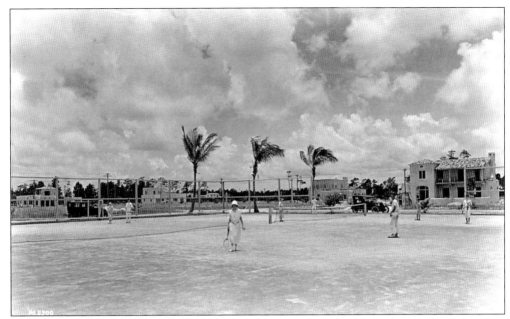

The tennis buffs were not overlooked! The city's courts were used from day one, and the open spaces next to and behind the courts, along with the player's attire, are testament to the early vintage of this Fishbaugh photograph.

People needed a quiet place to rest, relax, and contemplate, as well as just to sit and talk, and numerous plazas and cozy retreats were built throughout the city. This is Ponce de Leon Plaza c. 1925.

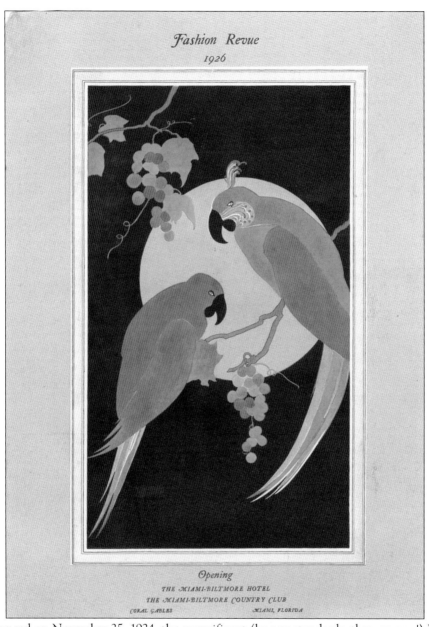

Fashion Revue
1926

Opening
THE MIAMI-BILTMORE HOTEL
THE MIAMI-BILTMORE COUNTRY CLUB
CORAL GABLES MIAMI, FLORIDA

Announced on November 25, 1924, the magnificent (by any standards, then or now!) Miami Biltmore Hotel opened on January 14 and 15, 1926. Designed by the famed New York architectural team of Schultze and Weaver, the cost, including the country club, would exceed $10 million, an unheard-of figure for South Florida at that time. The grand highlight of the hotel was the tower replicating the Giralda Tower in Seville, Spain, and it was in that tower, overlooking all of Coral Gables, that Merrick would have one of his private offices. Although the opening-night menu is on loan to Miami Beach's marvelous Wolfsonian—FIU Museum of the Decorative and Propaganda Arts, presented here is the *Fashion Revue* booklet, published for a major event featuring famous models and designs from haute-couture firms held at the Biltmore on opening weekend. This great event made news as far away as New York and Chicago and was written up in newspapers, magazines, and in an especially glowing manner by the fashion press of the day.

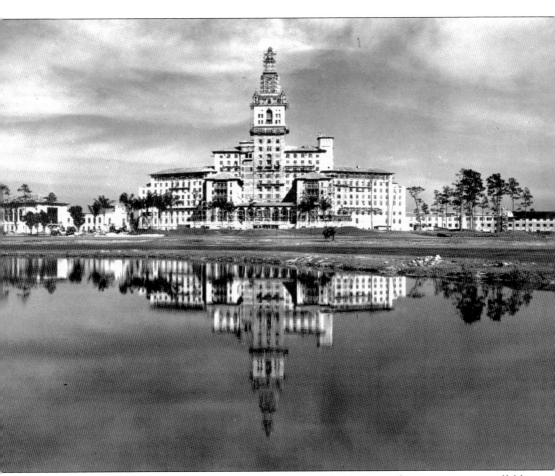

An extremely rare view of the hotel from the rear (south) side shows the construction scaffolding still in place.

Dining at the Biltmore was (and is) a special event. One of the columned-loggia outdoor dining areas is shown here set for an opening-weekend luncheon event.

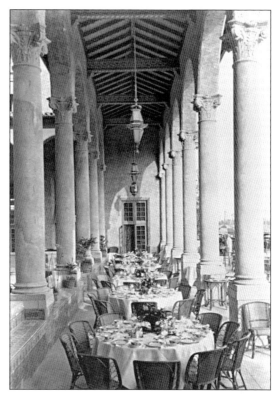

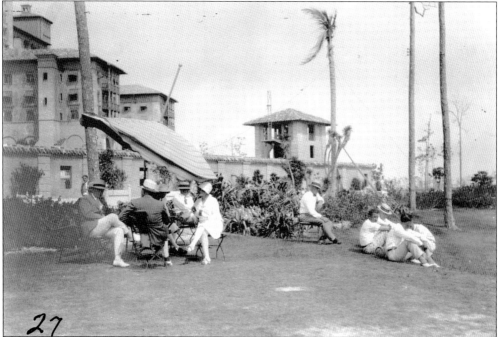

The hotel was a place to relax and rejuvenate, and both individuals and groups enjoyed the interiors and the grounds of the beautiful building —as they would until the military took over the property in 1943. This view was made, as can be seen by the fashions, shortly after opening.

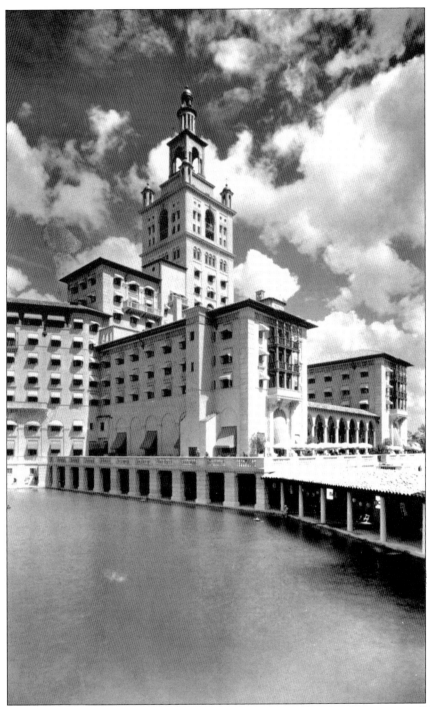

Not since the legendary Henry M. Flagler built the Alcazar Hotel in St. Augustine in 1887 and 1888 had a hotel swimming pool been as immense or as stunningly beautiful as the Biltmore's. A view of the rear veranda shows just a part of the incredible aquatic facility, which, until they had their own on-campus heated pool, was used as the practice and meets pool by the University of Miami's swimming and diving teams.

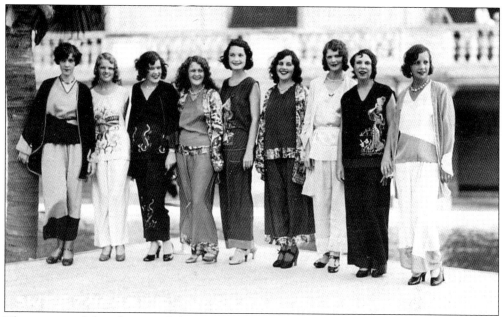

The caption of this photograph by an unknown lensman is "Sweethearts on Parade, Miami Biltmore Hotel," and, indeed, this group of nine women is stunning. The photograph was taken during opening season, and it is almost painful to expostulate over the fate of these beautiful women and further wonder how many are still with us today.

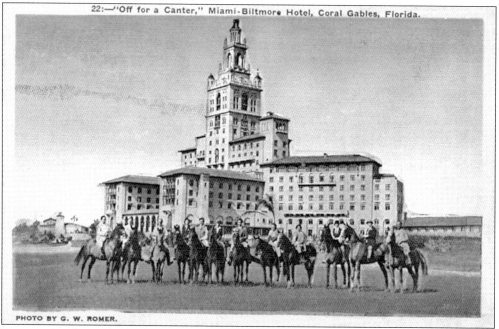

22:—"Off for a Canter," Miami-Biltmore Hotel, Coral Gables, Florida.

PHOTO BY G. W. ROMER.

So attuned to the public's wishes and desires were the Merrick people that no detail of entertainment or amusement was overlooked. The corporation even saw to it that those staying at the Biltmore could enjoy horseback riding if that was their desire.

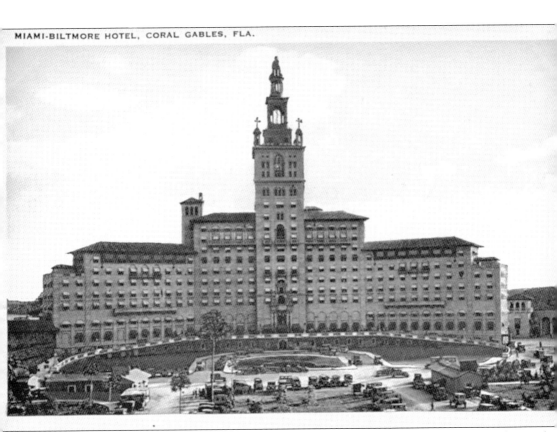

Seen from the front, the grandiosity and enormity of the hotel becomes even more evident and the scope of the project even more impressive. Even with all of the new high-rises in the city, the Biltmore is still the architectural masterpiece of Coral Gables.

CORAL GABLES
Miami Riviera
40 Miles of Water Front
GEORGE E. MERRICK

CORAL GABLES, MIAMI, FLORIDA

Feb. 1, 1926.

Mrs. J. L. Lohman,
116 Beverly Court,
Daytona, Florida.

Dear Madam :—

The Beauty Parlor reservation in the Urmey Arms had been taken before you applied. If you are interested in another location on a main thoroughfare or in a new hotel I shall be glad to assist you in obtaining it.

Very truly yours

D. R. Fuller

Daytona Fla.
March 24-26.

The rush to buy in Coral Gables was becoming frenzied, and millions of dollars a day were being committed for homes, apartment houses, and commercial space. This letter, written by D. R. Fuller on February 1, 1926, tells the story, as he is explaining to a woman in Daytona, Florida, that the space for the beauty parlor she hoped to open in the Urmey Arms Hotel (never built) was previously sold, but that he would work with her to find her another acceptable location. It would all come crashing to an end in just a few short months.

HURRICANE MIAMI RIVIERA EXTRA
OF CORAL GABLES

SEPTEMBER 19, 1926 CORAL GABLES, FLORIDA

From George E. Merrick

The damage done to Coral Gables by the hurricane is for most part on the surface and can be rapidly repaired. The principal damage to the appearance of the city is to the landscaping. The great majority of the trees and shrubs that have been blown down can be replanted and will be save. This will be carried on immediately by the City of Coral Gables and funds for that purpose are available. She damage done to the various buildings owned by the Coral Gables Corporation will be repaired by the corporation at once and the finances to do this repair work have already been secured. General reconstruction headquarters have been located in the Construction Building at the corner of Ponce de Leon Boulevard and Avenue Aragon, with Rodney Miller in supreme charge. All matters affecting repairs, clearing of streets, water, etc., should be referred to Mr. Miller. Relief headquarters have been opened in the same building under the auspices of the Coral Gables Chamber of Commerce, with F. J. O'Leary, President, in charge. All matters affecting food supplies, housing or shelter and relief measures generally should be referred to Mr. O'Leary. The police department under Chief Lehman, recruited by the addition of a number of deputies, is looking after the safety of the community. Do not be alarmed as the general situation will soon clear up and we are well organized to care for any emergencies. The Tallman Hospital at the corner of Douglas Road and Cocoanut Grove Drive is equipped to care for any sickness or accident.

I went to appeal, personally, to the owner of every home in Coral Gables, to see that his new property is repaired at once. We cannot carry the burden of this work, as well as the necessary repairs to the general property. Restore your own planting; every tree that has been blown down and every shrub, if properly re-planted was supported, will grow and be saved. Board up your houses until glass can be obtained to repair broken windows. Take down all torn awnings and remove all debris. If this work is done by every property owner, in two month's time we can remove every trace of the hurricane in Coral Gables.

Remember that this is the time when we must all stand together. The damage has not been nearly so great as it appears at first glance. Let us take pride in restoring our city to its condition before the storm at the earliest possible moment. Our hotels are all in commission and will do all in their power to care for people in need of food and shelter temporarily.

In order to coordinate the efforts of everyone towards relief and reconstruction, be sure that all efforts along these lines are concentrated in the construction building.

I am ant at all discouraged by the situation and all that we need is the co-operation of all Coral Gables people to repair such damage as has been done.

GEORGE E. MERRICK.

List of Dead

The dead are, none from Coral Gables;

T. V. AYARS, age 29, Coconut Grove.
MRS. MATTIE BRINSON, aged 60, South Miami.
DORIS WALLS, aged 8, South Miami.
MRS. JOSEPHINE CRACRAFT, aged 52.
JOHN PETTY, aged 18, Coral Terrace.
MRS. McGINNIS, aged 28, Coral Terrace.

Riviera plant totally destroyed. Work starts to-morrow morning on new plant. This edition printed by hand at the Parker Art Printing Association.

Facts about the Hurricane

Reconstruction well under way almost before hurricane ended.
Government barometer registered 27.75 during storm, the lowest ever recorded, Galveston flood having been only 29.
The first in the Miami district in 23 years, and the most severe eder recorded. Hurricanes in two sections, one from the north from 3 to 7 a.m., Saturday, Sept. 17, the other from the south, 8 to 11:30 a.m.

Second hurricane more serious than first, most of the damage to Coral Gables section having been done then.

F. J. O'Leary crossed the causeway from Miami Beach Sunday morning to help with reconstruction. He is in charge, of relief work assisted by W. P. Frost.

Rodney Miller, in charge of buildings; Warren Rishel of relief at Country Club; Sanford Craven of streets; Gilbert Chaplin of supplies for the injured; Mrs. Denman Fink of Red Cross. Mrs. J. L. Williams of the Women's Committee at the Congregational Church, supplying bed clothes for homeless. Major Patterson, Dr. Powell, John Norman, G. G. Dockrell, also on committees; Dr. A. F. Allen looking after the injured.

None known dead in Gables.

Many injured to the west and south.

Tallman hospital crowded with hurt, and city's resources turned over to help stricken neighbors.

Biltmore feeds and shelters 2,000 homeless Saturday night.

City under citizens committee, with police on full time duty since Friday night.

No one allowed to enter or leave city without official permit.

Twenty-four hour ration ticket being issued for gasoline, ice, food, building materials.

Plenty of food and water for everyone.

Relief headquarters at 2330 Ponce de Leon Boulevard. Construction Bldg. Bank open all day every day, and merchants selling at regular prices.

Reported that hurricane extended no further north than Ft. Lauderdale. Ice plant and bakeries operating. Cots and bedding needed. Gables least damaged in district. Venetian Causeway open.

Mayor's Proclamation

The present emergency occasioned by the hurricane demands that all of the citizens of Coral Gables unite in a co-ordinated effort to care for those that are in need, and to repair such damage as has been done to the city.

As Mayor of the City of Coral Gables, I call upon every citizen to do his utmost in the work of reconstruction and to volunteer his services to the relief committee which has been organized under F. J. O'Leary, President of the Chamber of Commerce, to handle all food and housing and other relief measures. The headquarters of the Relief Committee is located in the Construction Building, at the corner of Ponce de Leon Boulevard and Avenue Aragon.

Be sparing in the water you use; we have a sufficiency for everyone if carefully used. Use the minimum amount of food until avenues of supplies are reopened. The City of Coral Gables has a most efficient police force and will Carefully protect the city. Guard carefully against fire damage through the use of candles and kerosene stoves. Do not touch trees in the streets or parkways which are uprooted because these trees can be saved; do not touch landscaping work. By intelligent handling, most all trees and shrubs can be saved.

Every department of the City Government will lend all possible assistance to our citizens.

EDWARD E. DAMMERS,
Mayor.

We Build A GREATER CITY

On September 17 and 18, one of the most horrific hurricanes ever to hit South Florida roared across the lower portion of the peninsula, striking downtown Miami, Miami Beach, and north and southwest Dade (including Coral Gables) almost as if they were the destination point for an arrow headed toward a bull's-eye. The day following the hurricane, the corporation, through its *Miami Riviera* medium, published the first of what would be, for several weeks thereafter, an almost daily *Hurricane Extra* assuring that all was well. It wasn't. Coupled with the capsizing of the four-masted schooner *Prinz Valdemar* at the mouth of the Miami harbor, the hurricane was the harbinger of what, just three years later, would be the beginning of the greatest depression America had ever faced. This extremely rare issue, the first post-hurricane, contained a message from George Merrick and a proclamation from Mayor Dammers. Though reassuring, the words could not and would not staunch the exodus of people, money, and confidence from the region, and the Gables that Merrick and Dammers knew would not survive the debacle.

Three

A GREAT PAN-AMERICAN UNIVERSITY

The idea for a great and major seat of higher learning in the Greater Miami area sprang up simultaneously from several groups and individuals.

Judge William E. Walsh organized the provisional board of regents, which applied for and received the charter for the university in 1925. Nationally famous orator and presidential candidate William Jennings Bryan may have been the first to propose the idea for a university, but he died on July 25, 1925, never to see his dream realized. Another key planner was Thomas J. Pancoast, president of the Miami Beach Chamber of Commerce and son-in-law of John Collins, one of the builders of Miami Beach. Also instrumental was Frederic Zeigen, who would become the first chairman of the Board of Regents of the University. Isadore Cohen, the first Jew to settle permanently in Miami and leader of Miami's growing Jewish community, helped spur university plans as well. Other organizers included Miami mayor Everett G. Sewell and, of course, Dammers and Merrick.

Initially, Miami's civic leaders rushed to be part of the planned initiative. But little occurred until Merrick pledged $5 million with the proviso that it be matched by donations of others, while simultaneously giving 160 acres of land for the university.

Work began on January 14, 1926, and the cornerstone was laid on February 4. Building and fund-raising continued for months, and Miami's boom, then at fever pitch, fueled the optimism. On September 12, the *Miami News* reported that the work on the Anastasia Building was being rushed, and that it would be ready for the opening on October 15. Five days later, the hurricane of September 17 and 18 put the university on close to mendicant footing almost until the beginning of World War II. Pres. Bowman Foster Ashe's belief in the future and a tenacious group of trustees were what saved the university from an early exit to oblivion.

When the university opened on October 15, 1926, it barely resembled the grandiose plans of the founders, many of whom were, like the school, on the edge of financial ruin. It was unclear then that worse was to come before any measurable progress.

Somehow, through the work of Dr. Ashe and many others, the University of Miami survived, thrived, and prospered and today is internationally renowned. The legacy of Merrick, Zeigen, Pancoast, Dammers, Jack Baldwin, Telfair Knight, Isadore Cohen, William Jennings Bryan, Dr. Ashe, and so many others lives on today at the great seat of learning that is the University of Miami at Coral Gables.

ℒaying of the corner stone of the Administration Building, University of Miami, the building presented as a gift by George E. Merrick in memory of his father, Solomon G. Merrick.

Opening Ceremony

Singing by children of Dade County Public Schools, under direction of Miss Bertha M. Foster, President of Miami Conservatory of Music, and Miss Sadie Lindenmeyer, Supervisor of Music in Dade County Public Schools, accompanied by Jan Garber and his Coral Gables Orchestra.

Opening Address
Judge William E. Walsh
Chairman of the Board of Regents of the University of Miami

Address by Honorable Frank B. Shutts
Member of the Board of Regents of the University of Miami

Address by Honorable Fons Hathaway
Personal Representative of Governor John E. Martin of Florida

Address by George E. Merrick

Address by Hamilton Holt
President of Rollins College, Winter Park, Florida

The Laying of the Corner Stone
Frederic Zeigen
Managing Regent, Board of Regents, officiating

Prayer by Reverend Thomas Benjamin Powell
Pastor Coral Gables Congregational Church

Flag Raising
Harvey Seeds Post Drum and Bugle Corps
Star Spangled Banner

Doxology

It is possible that, with the exception of the shovel used for the breaking of ground for the university, this piece—the invitation to the laying of the cornerstone of the school on February 4, 1926, and the only one known to exist—may be the single most valuable piece of University of Miami memorabilia in existence. With songs by Dade County public-school children; the opening address by Judge William E. Walsh, chairman of the University of Miami Board of Regents; and following addresses by attorney and board member Frank B. Shutts; Fons Hathaway, a representative of Florida governor John W. Martin; Merrick; and Hamilton Holt, president of Rollins College; Frederic Zeigen, managing regent of the board of trustees, officiated for the laying of the cornerstone of the university. The building was presented as a gift by Merrick in memory of his father.

February 4, 1926 was, in the vernacular, "a mite airish out," but the weather, though crisp and nippy, did not dampen the enthusiasm of the participants in the laying of the cornerstone. Looking up at the dignitaries platform, one can see Merrick, with Dr. Dammers to his left, addressing the crowd, the cornerstone in front of them being held up by a winch and pulley.

Chairman of the University's Board of Regents Frederic Zeigen, in light colored suit, has taken his place next to the podium, his back to the camera preparatory to his remarks and the official lowering of the cornerstone into its honored place (see page 68).

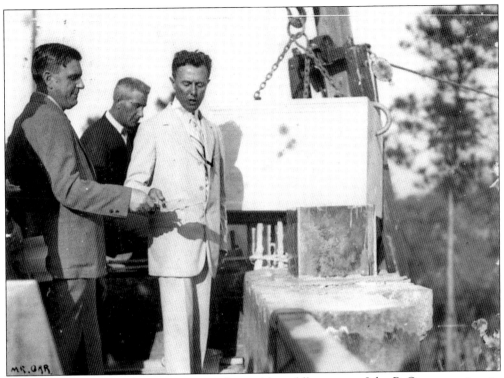

Chairman Zeigen takes the cement-covered trowel from fellow trustee John B. Orr preparatory to the ceremonial lowering of the cornerstone, the act that would begin the physical construction of the building that, due to the September 17 and 18, 1926, hurricane, would not be completed or occupied for many years but which today stands in testimony to the loyalty, dedication, and perseverance of the University of Miami's pioneers.

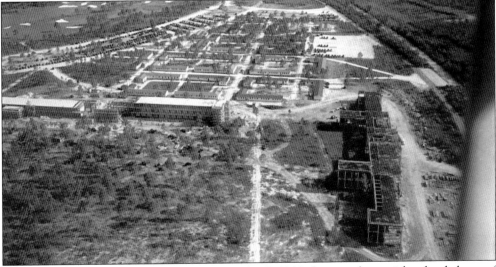

This photograph, taken from the air on November 7, 1946, shows, at lower right, the skeleton of what would eventually open as the Merrick Building. Even then, more than 20 years following the laying of the cornerstone, the building was still an empty shell, as it would remain for several more years. (Courtesy University of Miami Special Collections.)

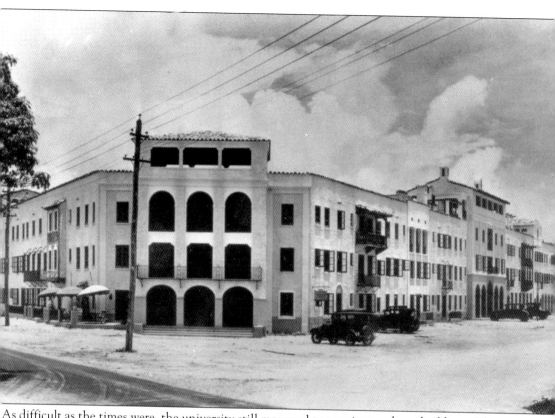

As difficult as the times were, the university still managed to acquire two large buildings. The San Sebastian building was originally built as a hotel at University Drive and Lejeune Road, and the Anastasia Building, planned as an apartment house and no longer extant, was a block southwest on University Drive. It was due to these purchases that the University of Miami (UM) was able to survive until World War II, when the influx of troops coming to Miami for training would take every available seat and space at the school, even though the buildings were known as "the cardboard college" because of the thin walls between dormitory and classroom spaces. Shown here is the San Sebastian Building, today a completely renovated and highly desirable condominium.

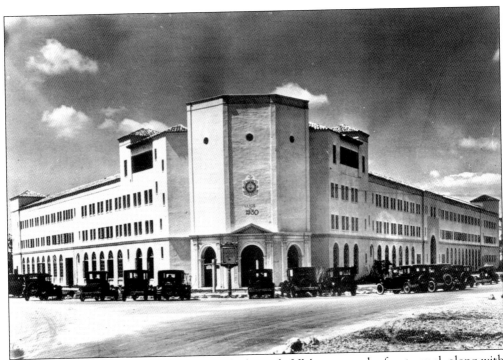

The Anastasia Building is shown here with the early UM crest on the front panel, along with the words "Class of 1930;" the class dedicated the insignia to the school.

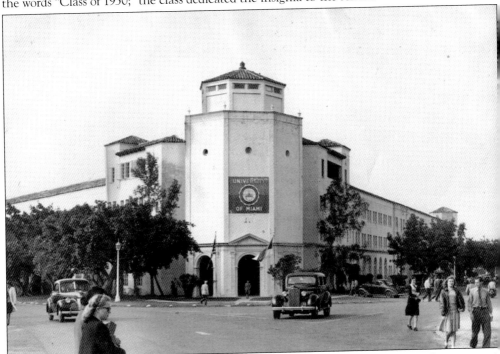

The building looks much the same several years later (c. 1942) except that a cupola now tops i off, and a large sign announcing the presence of the university is on the front, the "Class of 1930 lettering no longer extant. (Courtesy University of Miami Special Collections.)

UNIVERSITY OF MIAMI

The Pan-American Out Door University

OFFICE OF THE
BOARD OF REGENTS

MIAMI. FLORIDA

April 5th, 1926

Mr. Walter C. Roome
Box 891
Miami, Florida

Dear Mr. Roome:

 I have yours of the 2nd enclosing check for $100.00, installment on your subscription to the University due April 1st.

 Thanking you kindly,

 Sincerely yours,

 UNIVERSITY OF MIAMI

 By: *Thos J Pancoast*

 Treasurer

TJP/aw

This letter, dated April 5, 1926, and signed by school treasurer Thomas J. Pancoast, is significant not only because it has Pancoast's signature and lists the officers and regents, but because it also has, below the "University of Miami," the words "the Pan American Out Door University," and press releases for a good few years thereafter would, with the attached photographs, show students attending classes out of doors in the beautiful weather of the South Florida winters.

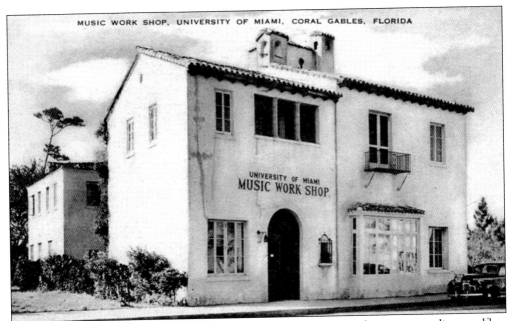

With much of the main campus still open land, the university found it more expedient and less expensive to purchase or rent existing buildings north of the area that would eventually be the center of activity, and the Music Work Shop building served the School of Music for a number of years prior to all classes and laboratories being moved to the original, Merrick-donated, 160-acre site that is now the UM in location as well as name. (Courtesy collection of Ron Gabor.)

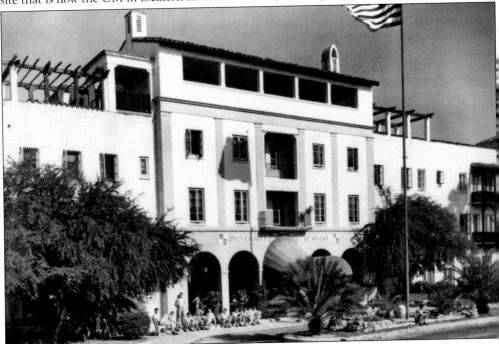

By World War II, every part of the university was alive with students, many—if not most—of them military cadets training for service in World War II. This view of the San Sebastian building shows cadets at ease between classes. (Courtesy University of Miami Special Collections.)

University of Miami
FOOTBALL PROGRAM

JIMMY O'BRIEN, *End*

MILLSAPS GAME
DECEMBER 17, 1927

15c.

DECEMBER 26: UNIVERSITY OF MIAMI *vs.* LOUISIANA COLLEGE

The university began its athletic program with football in 1926, going undefeated in the first season. Any UM football-related ephemera for that long-ago era, now 80 years in the past, is extremely rare, and this December 17, 1927, program for the game against Millsaps College is no exception. At six-and-an-eighth inches by nine inches, the program is loaded with pictures, facts, and information on the schools and the players, and it is complete with the 1926 record and wonderful advertisements from local businesses. And 15¢ to purchase the program was a lot of money back then! (Courtesy collection of Ron Gabor.)

By the late 1930s, Miami had become something of a football powerhouse and was playing its games in the Orange Bowl. Eddie Dunn, longtime UM football coach, was captain of the 1938 Hurricanes. Here, after beating Duquesne University of Pittsburgh, he is being congratulated by New York City mayor Fiorello LaGuardia.

Seventeenth Annual Commencement

of

The University of Miami

Monday, May 24, 1943

at eleven o'clock in the morning

THE GABLES THEATRE

Coral Gables, Florida

This is the 17th annual commencement program of the university, held on May 24, 1943, at the Gables Theater on Ponce de Leon Boulevard in Coral Gables. Because of World War II, a number of the graduates' names are shown with asterisks or other symbols to denote the fact that they had already left campus for wartime service. Among the prominent names, Harry Dansky and Malvin Englander appear. Englander would go on to become a highly respected Miami Beach attorney, justice of the peace, member of the city council, vice mayor, and father of a daughter who would be elected mayor of Broward County, Florida, as well as four other daughters (one a Broward County judge) and a son, all of whom would earn college degrees, two graduating from law school and two from Cornell University.

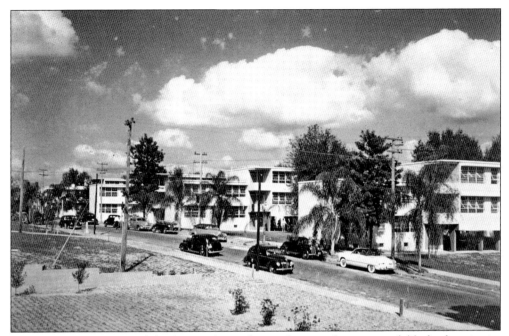

As the university grew and the financial crisis lessened, money became available for dormitories and classroom buildings. About 30 low-rise dorms were constructed along with new classroom buildings, and slowly but surely, the old barracks-type buildings and the portable wooden classrooms mercifully disappeared. This view, complete with cars from the late 1930s and 1940s, shows a row of newly built dorms.

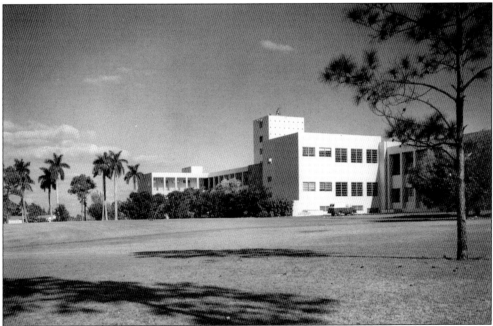

New classroom buildings came online and enrollment slowly increased. With the completion of the Merrick Building, the specter of the 1926 hurricane, the Depression that followed, and the skeleton of a building that had been started many years before vanished forever.

Four

CORAL GABLES RAPID TRANSIT COMPANY

George Merrick's vision for Coral Gables included a need for rail transportation between downtown Miami, then the epicenter of the area, and the Gables. In August 1924, he began construction of a trolley line that would operate north on Ponce from Coral Way to Flagler Street and then east on Flagler Street to Twenty-Second Avenue, where it would connect to the trackage of the existing Miami streetcar line. The system would enable the Gables cars to operate through to downtown Miami.

Purchasing five small, single-truck, Birney-type cars (numbers 101 through 105), Merrick realized that he also needed a high-speed route that would give him a loop to Miami, providing Coral Gables passengers with a choice of routes. Hence he embarked on the great Coral Way interurban project, building a line east on Coral Way, curving north at Five Points, where Southwest Third Avenue, Southwest Twelfth Avenue, Coral Way, and Southwest Twenty-Second Street come together, and continuing into downtown via Southwest Thirteenth Street and Miami Avenue to Flagler Street.

The cars, painted a bright coral pink, were a treat for the eyes, and with a fare of 10¢ that encouraged ridership, it seemed that the future of trolley-car operation was secure. Unhappily it was not.

Though the damage wrought by the 1926 storm was substantial, the system soldiered on, and though several money-losing lines were abandoned or shortened through the Depression, the two main lines continued to operate.

Unlike the Birneys, which seated about 32, the big interurban cars seated 52 and were equipped with larger and more comfortable seats. While the local cars took 40 and more minutes to get into town and were scheduled to run every 40 minutes throughout the day, the interurban line ran every 20 minutes and the cars would race down Coral Way at speeds approaching 80 miles per hour. The right of way was in the center of the great street, where the banyan trees now grow. But the rapid transit had problems. The line was not built on a grade-separated right of way and was interrupted by all the street crossings that would spring up.

It would be the hurricane of November 4, 1935, that would administer the coup de grâce to the system. Much of the overhead wire, along with numerous trolley poles and feeder cables, was decimated by the storm. Several of the streetcars, stranded on the line without power, were towed back to the barn by a dump truck. The city, still struggling financially, could ill afford to rebuild the system, and a marvelous part of the Coral Gables story would come to an unhappy and ignominious ending.

This photograph of Coral Way (later Miracle Mile) looking west toward the city hall and with the Colonade building on the right might possibly be the single greatest Coral Gables photograph ever taken! Besides the fact that, in this 1926 image, much of the street is still undeveloped, this may be the only photograph ever taken showing the trolley car passing siding on Coral Way, just east of Ponce de Leon Boulevard. Since the interurban line was single track, regular passing

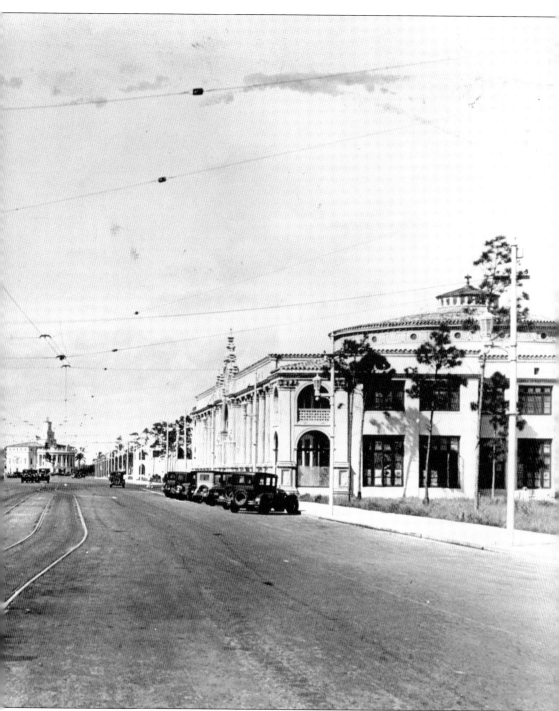

sidings were needed to allow cars moving in opposite directions to pass. In this marvelous view, the trackage can clearly be seen, as well as the switches at either end and the overhead wire, not to mention the buildings and the vehicles parked curbside. It was a grand and glorious moment in time for the city!

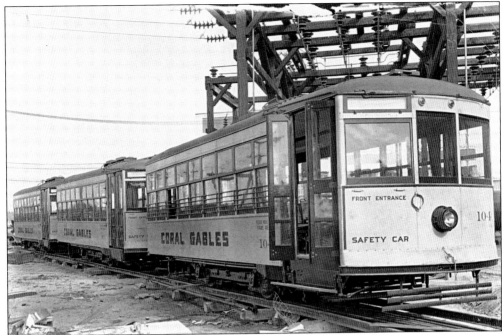

When the first order of single-truck Birney cars arrived, they were unloaded at the Florida East Coast Railway's Buena Vista Yard and taken to the Miami Beach Railway's Terminal Island facility at the east end of the County (now MacArthur) Causeway for inspection and detailing, and this 1926 photograph shows three of the original five cars preparatory to having their trolley poles (shipped separately) installed.

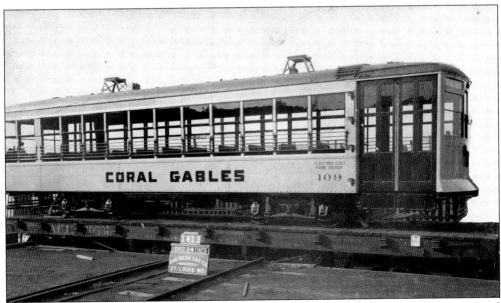

In addition to the two orders of single-truck, Birney-type cars, two lightweight, high-speed local cars were ordered from Brill subsidiary American Car Company. Number 109 is shown here on an Atlantic Coast Line flatcar awaiting departure from St. Louis to its South Florida destination.

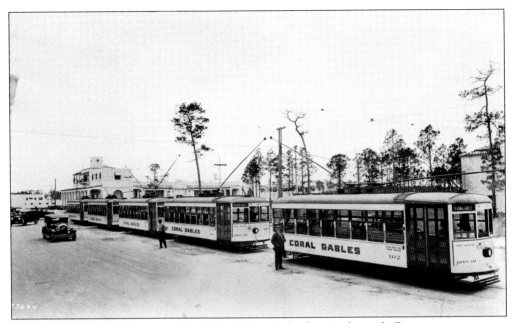

It is opening day for the system, April 30, 1925, and the five single-truck, Birney-type streetcars are lined up on Ponce de Leon Boulevard preparatory to the festivities inaugurating service on the line. It is believed that the gentleman standing next to number 102 with the straw hat on is Dr. Dammers himself!

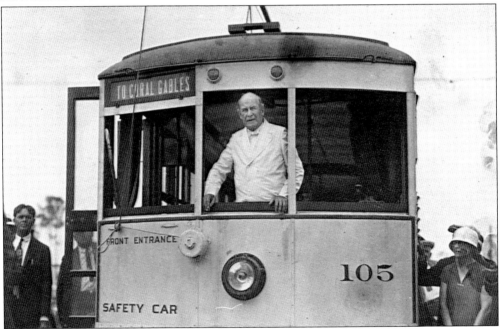

The speech he gave to open the street car line on April 30 would be the last public oratory that William Jennings Bryan, shown here in the front window of number 105, would ever deliver, his death coming scarcely three months later on July 25. More remembered for his lawyering facing Clarence Darrow in the famous Scopes trial than for his connection with Florida, he remains an integral part of South Florida and Coral Gables history.

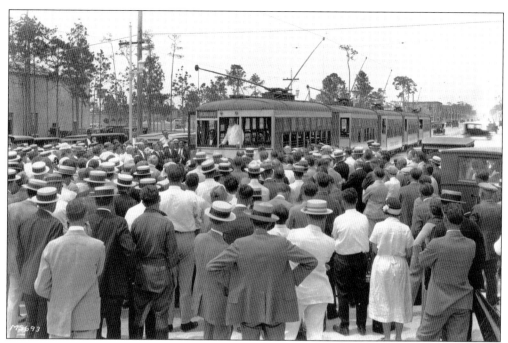

A wide-angle view of the crowd scene on opening day of the trolley line shows William Jennings Bryan, both hands on the car windowsill, extolling the virtues of Coral Gables and its brand-new streetcars.

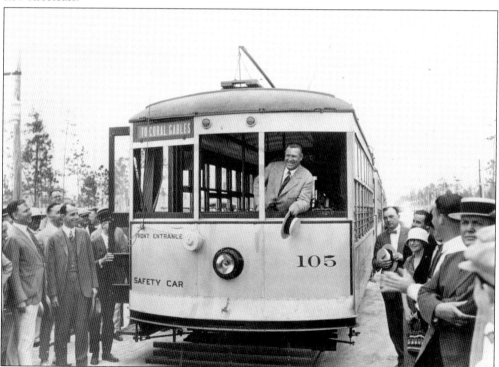

No event occurring in the Gables could be complete without Merrick, here smiling broadly just before the initial runs of the cars.

Interurban car number 4, with 52 seats, is shown at the builder's plant in St. Louis prior to being shipped to Coral Gables.

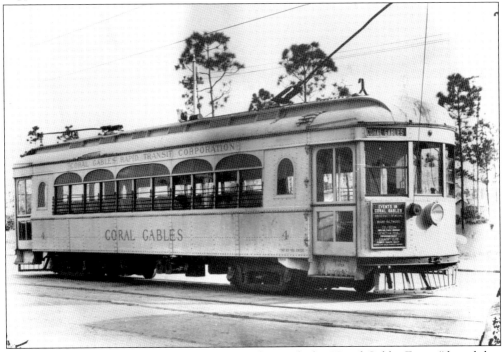

Number 4 is seen in service on Coral Way, complete with the "Coral Gables Events" board that all of the interurban cars carried. The board had space for updated postings about the University of Miami, the Miami Biltmore, the Coliseum, the Venetian Pool, and the country club.

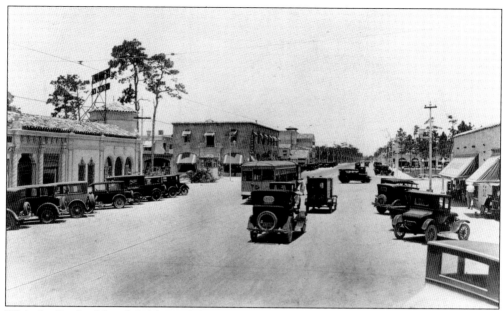

With the Bank of Coral Gables and the Century Building on the left, one of the Birney cars is loading a female passenger heading outbound on Ponce, destination downtown Miami.

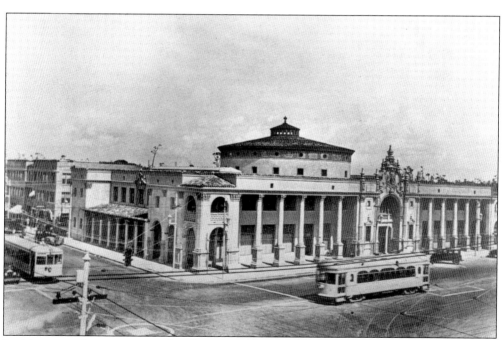

In this extremely rare view, number 2 is inbound on Coral Way at Ponce while one of the local cars is stopped on Ponce waiting to cross what would eventually become Miracle Mile.

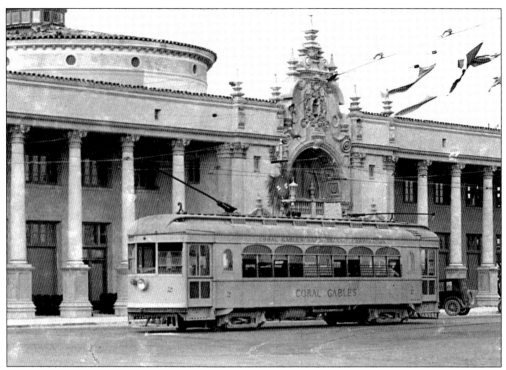

Interurban car number 2 is outbound (note which trolley pole is raised) and will shortly depart for downtown Miami via Coral Way, Southwest Thirteenth Street, and Miami Avenue.

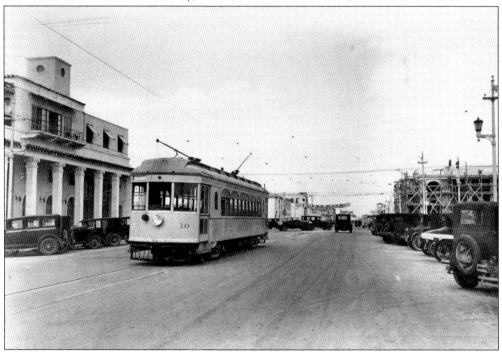

Car number 10 is awaiting passengers on Coral Way, while a UM football banner hangs over the street in the background, inviting fans to the next Hurricanes game.

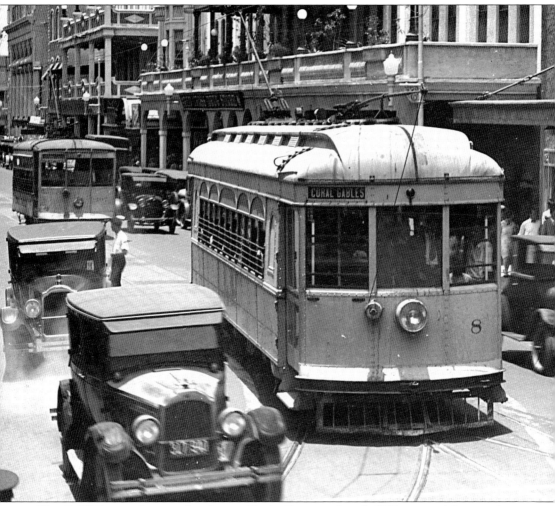

This G. W. Romer photograph, taken on Flagler Street on June 9, 1927, is one of the most famous Miami photographs ever taken, often used to show how busy the street was and the fact that Miami had trolley cars. What most people looking at the photograph are completely unaware of is that this is one of the few photographs showing both types of Coral Gables cars in Miami proper. Close to the camera, number 8 is making the turn from Flagler Street to Southeast Second Avenue; one block south it would turn west on Southwest First Street, proceed two blocks to Miami Avenue, and then turn south again to rejoin the Gables line. Behind number 8, local Ponce de Leon Boulevard–Flagler Street trolley 107 awaits its turn, although that car will make a complete loop and use Southwest First Street back to Flagler Street, go west to Ponce, and then return to the Gables.

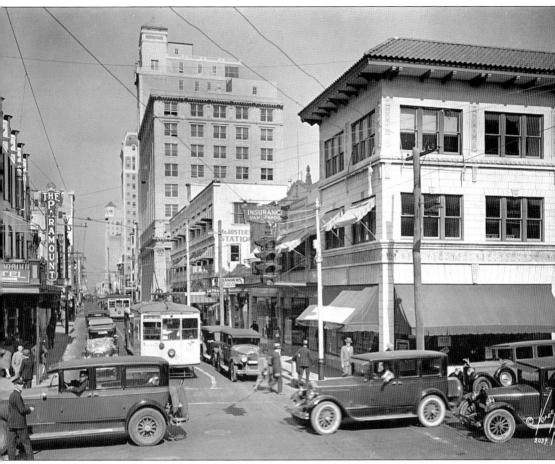

From the lens of another of the great 1920s- and 1930s-era Miami photographers, Verne O. Williams, comes this incredible view of a busy and bustling downtown Miami. Coral Gables Rapid Transit's number 107 is in the center of the street preparing for a right turn with City of Miami streetcar number 234 less than a block behind.

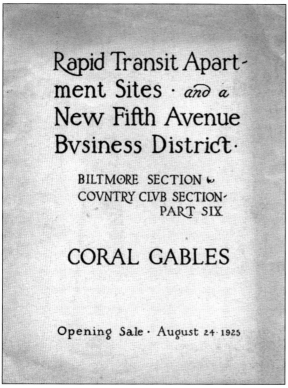

Rapid Transit Apart-
ment Sites · *and a*
New Fifth Avenue
Bvsiness District·

BILTMORE SECTION ~
COVNTRY CLVB SECTION·
PART SIX

CORAL GABLES

Opening Sale · August 24·1925

Merrick utilized the idea of rapid transit to his and the corporation's fullest advantage. This August 1925 booklet promotes "Rapid Transit Apartment Sites and a New Fifth Avenue Business District." Fifth Avenue refers to Biltmore Way and is not meant to be implied as a street renaming. The 1926 hurricane, the Depression, and the 1935 hurricane would end "the time of the trolley" in Coral Gables history.

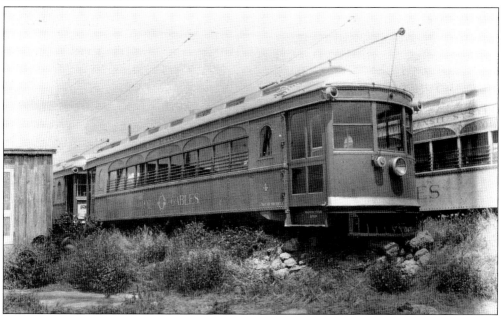

After the decision was made to abandon the streetcar system, the cars sat, forlorn and neglected, at the Ponce de Leon trolley barn. One by one they would be sold for use as residences, chicken coops, or diners, until today nothing is left of the interurban era of this great city save the photographs, tokens, tickets, and paperwork rescued and salvaged by the author and too few other Miami memorabilia collectors.

Five

FROM BOOM TO BUST TO BANKRUPTCY

Although Merrick and his staff put on a show of bravado following the 1926 hurricane, the handwriting was clearly on the wall, and as more and more buyers defaulted on their loans, it became ever more difficult for the corporation to meet its obligations. Finally, in 1929, Merrick issued a series of short-term bonds in the form of debenture trust notes, but even that was not enough, and by 1930, even with the municipality's 1929 reorganization, both the city and George Merrick were in complete default.

Fortunately for George, Eunice's father had left them property in 1930—a small fishing camp on Matecumbe Key—and the Merricks would for several years operate Caribee Colony as a rustic Florida Keys resort, not returning to real estate until 1934. In 1935, the great Labor Day hurricane ripped through 40 miles of the Keys, destroying much of the Florida East Coast Railway's Key West Extension and wiping out Caribee Colony.

Coral Gables, which had in one year issued permits for $25 million in new construction, was by 1932 at its lowest point: only four new buildings were built, with a total permit value of just over $71,600.

Although the city was in dire financial straits, the city fathers wisely refused to relax the rigid architectural and building standards which had been put in place by Merrick, architect Fink, and Phineas Paist, and it was that insistence on quality and a refusal to allow any form of cheap or inferior construction that would set the standard for, and preserve the integrity of, the city as we know it today.

On June 1, 1940, Merrick was appointed postmaster of Miami (which included Coral Gables) and served on numerous civic boards and commissions. Greatly beloved, he was awarded honorary lifetime membership in the Coral Gables Chamber of Commerce that same year.

In 1942, at the age of 56, George Merrick passed away, leaving a legacy of greatness equaled only by the absolute upper echelon of the most famous and revered Florida names, and his life and work are memorialized throughout South Florida, particularly, of course, in Coral Gables, where he has deservedly achieved iconic if not legendary status.

Exceedingly rare, and very rarely surfacing, the last-ditch debenture trust notes were Merrick's final grasp at retaining solvency. Issued on May 9, 1929, they were due on May 9, 1931, nothing being paid due to the almost complete lack of funds or assets by that time. Almost all were shredded following their being turned in, and the very few that remain are in private collections.

Depression, bankruptcy, and financial instability or no, the city bravely soldiered on and for the 1932 winter season published this two-fold, three-panel brochure listing all of the activities going on in Greater Miami and Coral Gables that season, the back cover reserved for ads for Coral Gables recreation venues, including the Venetian Pool, the municipal Granada Golf Course, the municipal tennis courts, and the country club.

90

"Little French Village"
Coral Gables, Florida
181

17,799

Part of the original plan for the city called for a series of "villages" of two to five homes in different areas of the city, each built in an architectural style reminiscent of that geographic locale and including Dutch South African, Chinese, French, Italian, and Florida Pioneer based on the Georgia Colonial architectural style. Surviving through the Depression, several are still extant, and shown below is the "Little French Village" on Ferdinand Street.

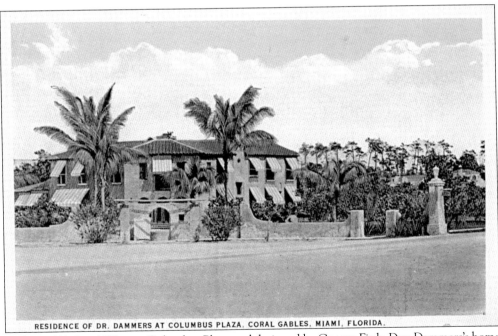

RESIDENCE OF DR. DAMMERS AT COLUMBUS PLAZA, CORAL GABLES, MIAMI, FLORIDA.

Built at 1141 Coral Way on Columbus Plaza and designed by George Fink, Doc Dammers's home was one of Coral Gables' largest residences. (Courtesy collection of Ron Gabor.)

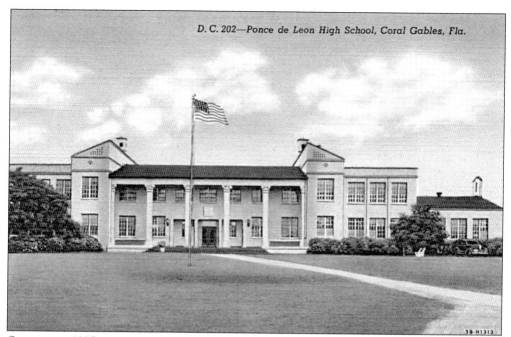

D. C. 202—Ponce de Leon High School, Coral Gables, Fla.

Opening in 1925 at 1100 Augusto Street, Ponce de Leon High School was the high school of Coral Gables, but in 1950, the new school known as Coral Gables High School opened. Ponce de Leon High School would continue as a center of learning as a junior high (today a middle) school. The front of the building is shown in this rarely seen 1930s view.

The high school's band, shown here, was known as the Ponce de Leon Coral Gables Marching Band and was sponsored by the city's Kiwanis Club.

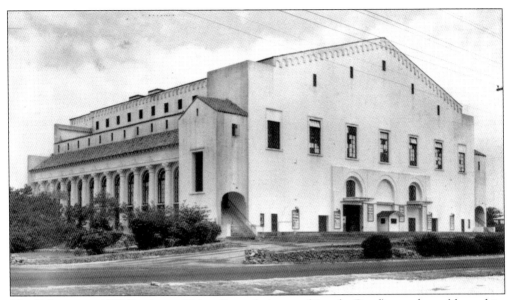

The Coliseum, at 1500 Southwest Thirty-Seventh Avenue (Douglas Road), was almost like a white elephant. Built in the mid-1920s, it was originally constructed as an ideal place for conventions and groups, but through the years it rarely showed a profit. It served as a meeting hall, bowling alley, ice skating rink, professional hockey arena, and in several other guises until, finally, unused and abandoned, it was torn down in the late 1970s. It was massive and could have been put to better usage, but newer arenas and changing interests doomed the building, the exterior of which is shown here in 1949. (Courtesy University of Miami Special Collections.)

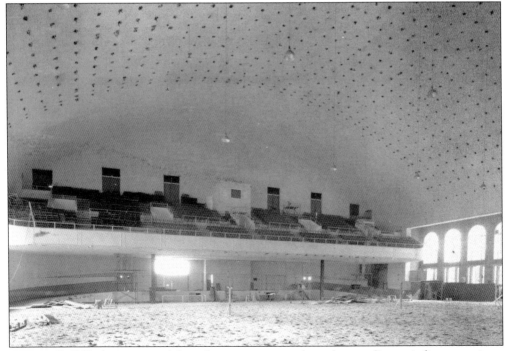

On June 7, 1957, the interior of the coliseum was going through one of its periodic renovations, and these changes would occur each time a new owner or group would purchase the building.

In 1924, Coral Gables Military Academy opened. It later became Merrick Demonstration School. Very little remains to commemorate its existence. Fortunately, this 1926 invoice tells that the fee charged was $68.70 and that laundry cost $8.95. It cannot be verified if those numbers were for a month or a term.

Coral Gables has been home to no few unique business and enterprises, and somehow Miri-Ko, "The Miracle Drink," thrived until sometime in the Depression. Located at 42 Avenue Almeria, the company's original phone number was Coral Gables 560.

Opening in January 1926, the Biltmore was sold to Alfred E. Smith and his associates in the fall of 1929, then resold by them to Col. Henry Doherty in 1931. Colonel Doherty, owner of the Florida All Year Round Club as well as several South Florida hotels, invested millions in restoring credibility to the area, going so far as to convince the Atlantic Coast Line Railroad and Florida East Coast Railway to operate a swimming pool—the only one ever in service on any American passenger train—on the all Pullman sleeping car *Florida Special* during the 1935–1936 winter season.

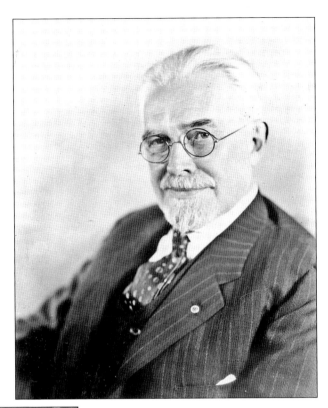

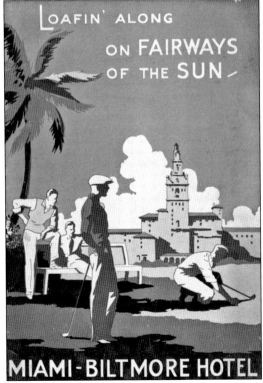

Like Merrick and John McEntee Bowman before him, Colonel Doherty poured immense amounts of money into the Biltmore, and this promotional golf booklet exemplifies his efforts to rebuild the business.

Gables residents participated fully in the various attempts to restore viability and vitality to the community. Beautiful young socialite Mrs. R. F. Lewis (shown in this April 23, 1935 photograph), as general chairperson of one of the benefit committees of the Coral Gables Junior Woman's Club, worked diligently to raise funds for those in need in the city.

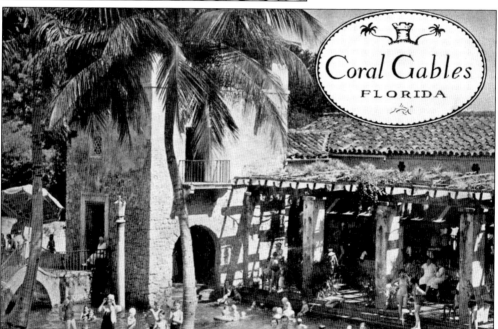

In 1938, as the Depression began to recede, the city issued this fine six-and-a-quarter-inch-by-seven-and-three-quarter-inch, 20-page booklet filled with beautiful photographs of all of the attractions, including the elegant homes, that gave people a reason to move to—and open a business in—Coral Gables.

Six

SURVIVING, REVIVING, AND THRIVING

The Depression wreaked havoc on Coral Gables, causing Merrick's bankruptcy and the city's financial default. Merrick had purchased the property of Charles LeJeune (for whom Lejeune Road is named) and increased the size of the city to 10,000 acres. But the city suffered a major blow when property owners sued the city for not providing them municipal services. As a result, the city lost ownership in 1935 of more than two square miles of land purchased in 1929, encompassing the space between today's Bird Road and Coral Way west of Red Road (Northwest Fifty-Seventh Avenue).

It got worse, and, as noted previously, the number and value of the building permits issued for construction in the city dropped precipitously. The November 1935 hurricane would be the direct cause for the cessation of trolley car service, and by January 1, 1937, the city's debt, including past due interest, totaled over $11 million.

Little by little, with careful fiscal management, the city emerged from the morass, helped to no small extent by the onset of World War II.

Almost overnight, Coral Gables became a huge barracks, and the university became a training center for thousands of U.S. Army, Army Air Force, and Navy personnel. The Biltmore became a military hospital and later the Veterans Hospital for South Florida before it was declared a national historic landmark in 1972. On April 27, 1973, the great edifice would be returned to city ownership. Today it is once again a magnificent hostelry and the pride of the city.

By 1947, the building department's permits totaled over $12 million, including more than $5 million spent to develop the university's original campus. Adding 85 acres to its property, the university grew to 245 acres and is today one of the foremost seats of learning and higher education in the country. The four blocks of Coral Way in the downtown area became Miracle Mile, and that stretch of the street is a major shopping, dining, and entertainment anchor for the city, while the Merrick Park development on Ponce de Leon Boulevard near U.S. Route 1 (South Dixie Highway) has attracted numerous national high-end retail department stores and boutiques.

The Coral Gables of today, with its beautiful homes, city-maintained parks and cultural venues, well-kept streets, modern fire and police departments, and a full range of city services, is one of the finest and most desirable communities in America in which to grow up, live, go to school, or operate a business in, and will continue to be for many, many years to come.

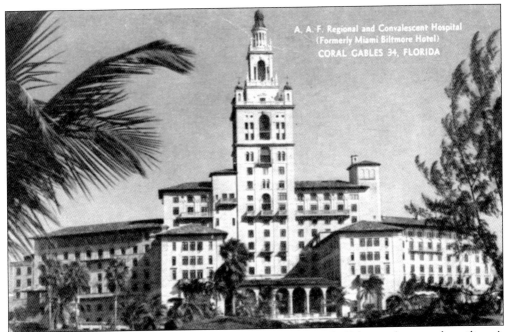

Taken over by the U.S. Army and the Army Air Force in 1943, the Biltmore became the military's regional and convalescent hospital for the duration of the war. Shortly after the war, the hospital was taken over by the Veterans Administration, and, after almost unbelievable machinations, the building was saved by the people of Coral Gables, its ownership returned to the city in 1973.

Though not within the city limits, one of the Miami area's most beloved attractions was at the corner of Bird and Southwest Eighty-Seventh Avenue (Ludlum Road). Famed for its trained ducks, Lost Lake was a totally unique and unusual place. Its verdant foliage and its small lakes, which were likely the result of limestone mining, created the rock pits that, filled with water, attracted the ducks that Tom Reed trained. Over 200 rare varieties of fruit grew on the property, and the Coral Caverns and Rock Garden, coupled with the glass-bottom boat tour, created an allure that made Lost Lake one of the favorite places of the Gablesites. Sadly the property was purchased and filled in, and today one passing that incredibly busy intersection would never know that such a wonderful venue existed.

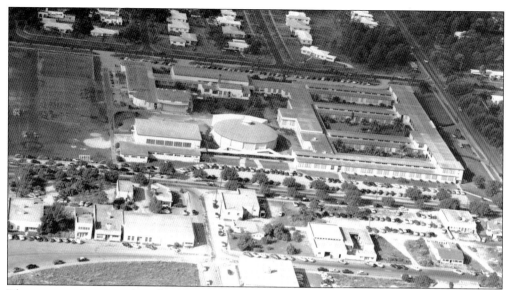

The trauma of moving the school was compounded with the name change from Ponce de Leon to Coral Gables High School. In a bow to tradition, the school's nickname remained "Cavaliers," and the yearbook name continued as *Cavaleon*. Taken several years after the move, on December 13, 1954, this marvelous aerial photograph shows the entire academic campus. Bird Road, on the right, goes east and west and is named for Molly Bird, whose home in Coconut Grove was across the street from the kindergarten school attended by Eunice Peacock. Below the school is Ponce de Leon Boulevard; the athletic fields are on the left.

One of the greatest staffs of high school football coaching talent ever assembled was that of Coral Gables High School. Under the direction of head coach Nick Kotys, Coral Gables won at least five state football championships and three national titles. Kneeling from left to right are coaches Jack McCloskey, Dan Finora, and Nick Kotys. Standing behind them are, from left to right, Sam Scarnecchia, Ed Injaychock, Joe Krutlis, Garry Ghormley, and Ed Beckman. (Courtesy Dan Finora, Coral Gables High School.)

At Miami Beach High School, the great cheer was "Beach is Dynuh-mite, Beach is Dyuhhnahmite!" At Miami High School, the chant was "Those Stingarees are the best, la dee dah." But everybody knew that the Cavaliers were on the move when the Orange Bowl rocked to "G-G-G-A-B! L-L-L-E-S! G-A-B-L-E-S—GOOOOOO GABLES!" In this marvelous 1969 view, the cheerleaders are posing for that year's squad photograph, showing the charm and beautiful smiles that went along with the great cheer! From left to right are Jane Ann Driver, Cathy Thompson, Ginger Perkins, Louise Robinson, Cathy Simmons, Dale August, Ann Billings, coach and sponsor Barbara Chitty, Vickie Norman, Joyce Mayers, Leslee Hancock, Gayle Andrews, Jeannie Eldridge, Ann Dunn, and Chris Pereno. Go Gables! (Courtesy Dan Finora, Coral Gables High School.)

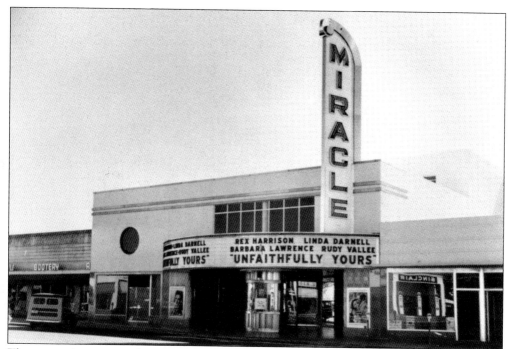

There were three movie theaters in the Gables, and each had its fans and aficionados. Today only the Miracle remains. It is shown in all its glory c. 1954, with a Jeep Woody parked at the curb to the left and the Sinclair gas station's pumps across the street reflecting in the store window on the right.

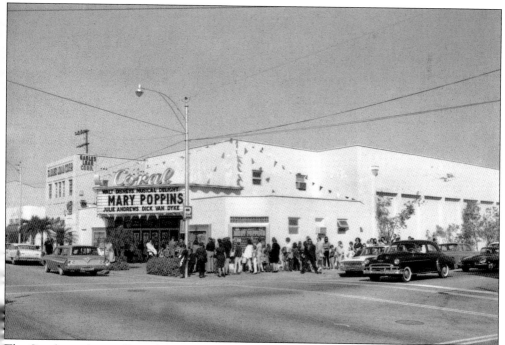

The Coral was the smallest of the three theaters, and in this c. 1959 view, the feature attraction is *Mary Poppins*.

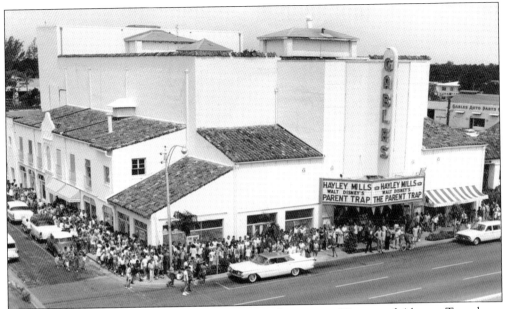

The largest of the three theaters was the Gables, on the corner of Ponce and Alcazar. Torn down for an office building, the memories of this wonderful showplace remain strong in the hearts of longtime Gables residents.

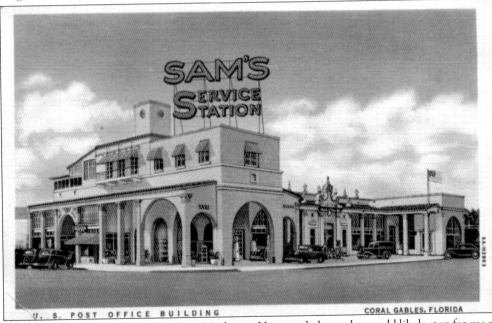

If one were heading for Tahiti Beach or Matheson Hammock, he or she would likely stop for gas at Sam's Service Station on the southwest corner of then Coral Way and Ponce de Leon Boulevard. According to Judith Weissel, Sam's daughter, the family's building was also home to the city's first post office, and it was because of Mr. And Mrs. Weissel's persistence that the contract station was awarded to them. The building was a mini–shopping center with a snack bar, soda fountain, auto-service facility, and taxi stand and was, prior to being torn down to be replaced by stores, a Coral Gables landmark.

U.S. Route 1—South Dixie Highway—was two lanes until the mid-1950s, and in this photograph from a family album, the beautiful and elegant University of Miami coed Myrna Meyers takes a break from classes to enjoy lunch at one of the several restaurants along the highway near the school. Following graduation and marriage, she would have two children who would also become Hurricanes: son Benjamin Nemser would receive both his baccalaureate and his law degree at Miami, and daughter Saralyn would earn her juris doctorate degree there.

Donated by the Matheson family, longtime Dade County residents and public servants, Matheson Hammock is a beautiful stretch of beach and park still enjoyed by not only Gablesites, but also by others who come from the southwest section for a happy day of sun and fun. And, best of all, it is, unlike Tahiti Beach, both free and still extant!

The Whip Inn was at 717 South Dixie Highway across from the university, and the building remained intact for many years, although it went through numerous name changes and physical metamorphoses.

One of the first shopping centers, this building remains intact across from the UM dorms and is shown later in its life on page 118. In this view, Food Fair, a supermarket chain, was the center anchor, and Woolworth's had a large store on the right. In front of the center is U.S. Route 1 (South Dixie Highway), paralleled by the Florida East Coast Railway tracks and Ponce de Leon Boulevard in front of the dorms, even then laden with UM traffic!

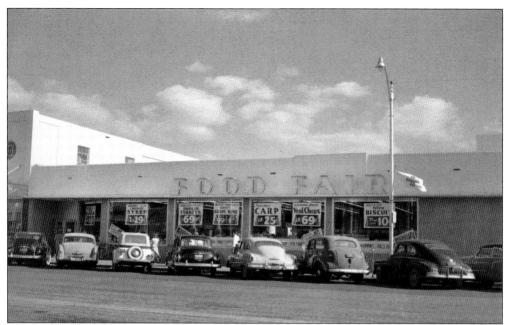

It was a different world when Food Fair opened at 152 Miracle Mile (it would later be incorporated into the Woolworth's next door). This view, made on April 8, 1952, shows the cars of the era. Note that, at that time, veal chops were 69¢ a pound, Welch's Kosher Sweet Grape Wine (must have been Passover!) was $1.39 a quart, and broiler turkeys were, like the veal chops, 69¢ a pound. Those were the days!

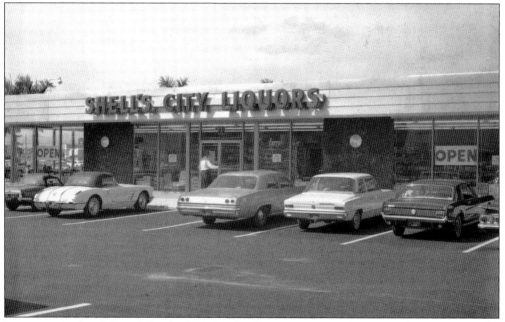

It was a major breakthough for the Weinkle family to gain approval to open a liquor store in the Gables. The then-new emporium at 35 Merrick Way is shown on November 21, 1967, complete with a Fiat Spider (or is that an Alfa Romeo at far left?), a Corvette, two sedans, and a 1966 or 1967 Mustang parked in front.

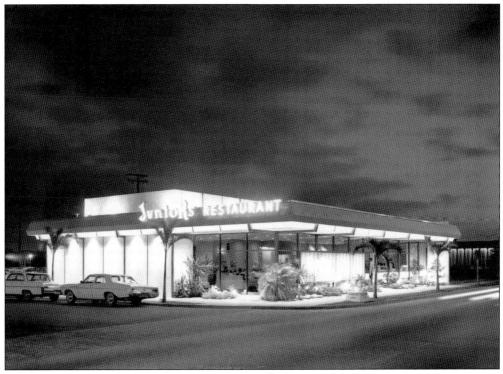

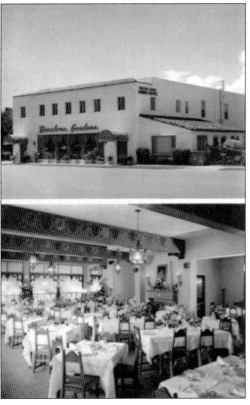

With tastes changing—and a willingness to expand their culinary interests—the people of the Gables embraced the new Junior's restaurant, a deli favorite with the same great food but more upscale than Wolfie's, Pumpernik's, and Rascal House. Owned by Arthur Horowitz, there were Junior's locations on Miami Beach, at Seventy-Ninth and Biscayne in Miami, and on Sunny Isles. This store on South Dixie Highway at Miller Road was for years a great favorite of both Gables residents and university students.

Barcelona Gardens, managed by Tony Damanda and located at 866 Ponce was, for many years, a great Gables favorite.

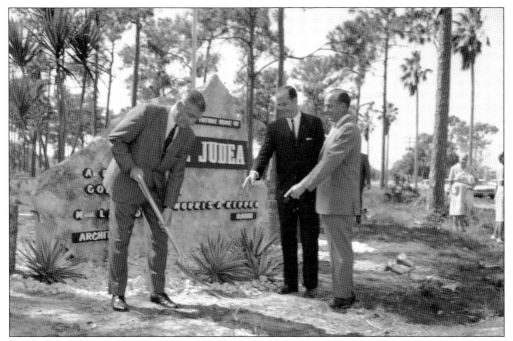

It was a major and very exciting day for the Jewish community of Coral Gables and the southwest section when the leaders of Temple Judea, at 5500 Granada, broke ground in front of the temple sign on November 24, 1965.

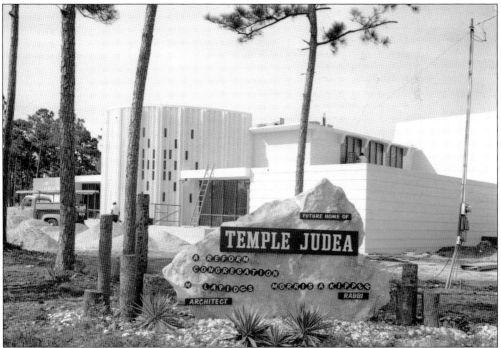

Almost eight months later, the temple is well on its way to completion. This view, taken from almost the same location on July 16, 1966, shows that the great Morris Lapidus, now famous for all of the Miami Beach hotels he designed—including the Fontainebleau—was the temple's architect.

Jimmy's Hurricane, with its sexy car hops, great burgers, terrific music, and all your friends there was, for 15 years, a true Gables landmark. The restaurant was at 3700 Bird Road. The sign was probably on Coral Way, as it shows the restaurant 19 blocks away.

Opened by Jimmy Ellenburg in 1951, the Hurricane closed for the last time on June 6, 1966. Adding covered parking in 1959 increased Jimmy's business, but eventually the property was sold for redevelopment.

When the Gables folks wanted barbecue, they could go to Shorty's, but that was a ride down South Dixie Highway through South Miami and into Kendall. Uncle Tom's, unpretentious but great, shown on August 23, 1961, was on Southwest Eighth Street just west of the Douglas entrance. Not quite in the Gables, it was just a couple of blocks outside, and as the barbecue aficionados liked to say, "close enough for government work!"

By the late 1950s and very early 1960s, two restaurants, both on Miracle Mile, had become the favorite gathering spots for both the younger crowd and the families, and both, every night of the week and on weekends, were "tumuling!" Jahn's was just a few doors west of Ponce on the north side of the street and was famous not just for its hamburgers, sandwiches, and ice cream, but also for "the kitchen sink," which consisted of every ice cream and every topping that the store had—that marvelous concoction was usually shared by at least eight people. The other "in spot" for the kids and the families was Chippy's, shown at 101 Miracle Mile, also on the north side. Somewhat quieter and more sedate than Jahn's, Chippy's was a full service deli-type restaurant.

Seen from the air on February 3, 1961, the Coral Gables bus terminal, complete with snack shop, newsstand, and other facilities, was a beehive of activity, as all bus lines of the Coral Gables Municipal System operated to and from this terminal, which covered a full block on Salzedo Street. Eventually the city would sell the bus operation to Dade County for incorporation into the county-wide system, and the entire block from Salzedo Street to Lejeune Road (on the right) would be leveled and developed for stores and offices.

In 1975, the then-new Gables police and fire station opened at 2801 Salzedo Street. It is shown here shortly after its opening.

This late 1950s–early 1960s brochure is the city's promotional piece for that time. It continued the advertising style initiated by Merrick in the early 1920s.

Published in 2002, this full-color, foldout map of the city opens to 11 inches by 32 inches and is completely updated. It features information and directions for a 20-mile, self-guided tour of the city.

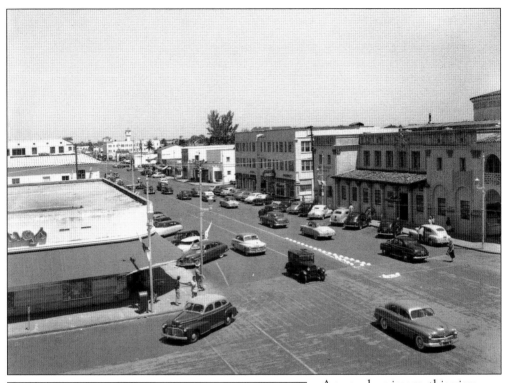

A marvelous image, this view looks north on Ponce from Miracle Mile around 1949 or 1950. The street sign on the close corner still says "Coral Way!"

For many years, the Elks Club was at 22 Giralda Avenue. For some years prior to the sale of the building for redevelopment as an office tower, the club was open to the public for luncheon dining, the wonderful food produced by Les Oppenheim of Special Events Catering, who, besides serving innumerable Miami and Gables families with marvelous catered affairs, is the provider of food and beverage services for the events at the Miracle Theater.

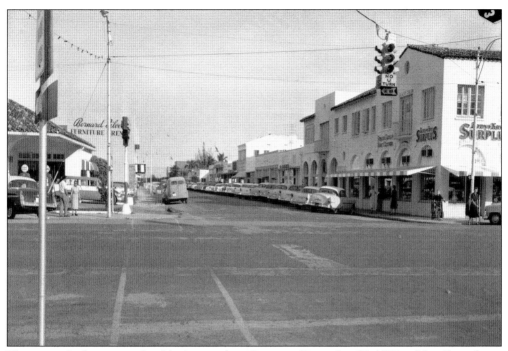

This image looks west on Giralda Avenue from Ponce on December 30, 1957, as New Years draws close and shoppers are making last-minute preparations for the gala event.

For many, the best baked goods in the area were either at Goren's Bakery on Southwest Eighth Street or at Andalusia on Andalusia Avenue. This very rare view shows the interior of Andalusia, the two smiling sales ladies eagerly awaiting the customers' selection of their wonderful pastries. (Courtesy City of Coral Gables Historical Resources Department.)

Orange Blossom, on Northwest Thirty-Sixth Street in Miami, was much too far to go, but the Hobby Center, on Southwest Eighth Street, was basically "right across the street," and for many years, it was the happy gathering spot for model railroaders and railroad buffs. Closing in the mid 1960s, it is still fondly remembered by adults who enjoyed the store so very much as kids.

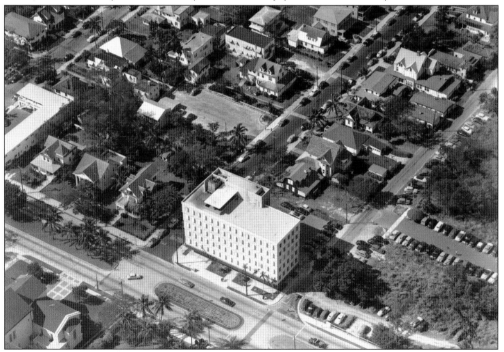

Though now overwhelmed by many high-rises, the first office building that was more than just a few stories was the 550 Building on Biltmore Way. At six stories, it was, at the time this photograph was taken on January 28, 1952, a "shock to the system" of the Gables.

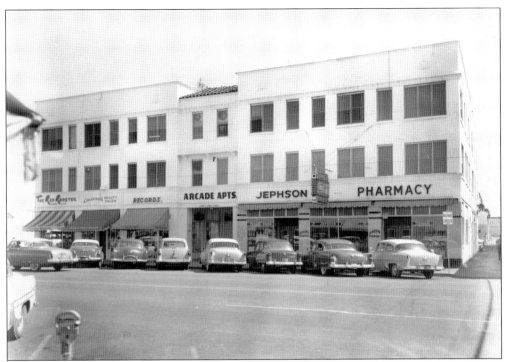

The Arcade Apartments were at 2347 Ponce de Leon Boulevard, with the Jephson Pharmacy on the south end of the building and the Red Rooster Gourmet Shop at the other. This photograph is c. 1953–1954.

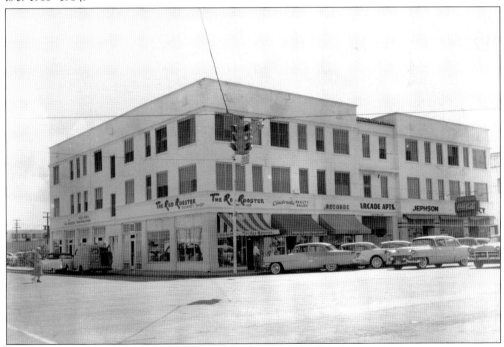

From the Aragon end of the block, one can see the east side of the Ponce and Aragon intersection, also c. 1953–1954, which looks quite a bit different today!

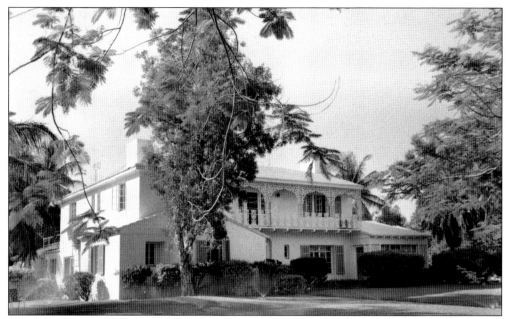

Because of the refusal, even during the Depression, to lower its standards, Coral Gables has maintained its property values at the highest levels while other communities in Dade County, taking the easy way out or allowing zoning variances, have seen tax collections fall dramatically as the worth of the property declined. This beautiful home, at 245 Catalonia, is indicative of the validity of the city's stand in regard to maintaining its integrity in the 1930s.

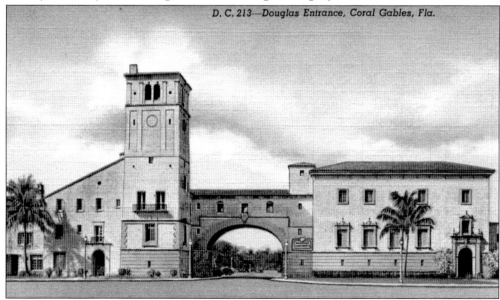

D. C. 213—Douglas Entrance, Coral Gables, Fla.

The Douglas Entrance to the city, at Douglas Road (named for John Douglas, who helped build the road) and Southwest Eighth Street, was one of Denman Fink's masterpieces of design. In concert with architects Walter deGarmo and Phineas Paist, it was originally called Puerta del Sol, or Gate of the Sun. Opened on May 21, 1927, at a cost of more than $1 million, the original plans called for, in addition to the entryway and the tower, two wings of galleries, shops, and apartments.

This booklet, with a full-color cover featuring the completed Merrick Building, was the 1958 promotional booklet of the university. It featured the fact that, at the time, 60 percent of the teaching faculty held a doctorate degree.

UNIVERSITY OF MIAMI
SCHOOL OF LAW
Hooding Ceremony

MAY 26

1985

DADE COUNTY AUDITORIUM

2901 WEST FLAGLER STREET

2:00 PM.

By 1985, the booklet for the hooding ceremony, at which University of Miami Law School graduates received their degrees, was 16 pages. The key address was given by the Singaporean ambassador to the United States. Among the graduates earning the juris doctorate degree was Saralyn Nemser, who would go on to become a Florida assistant attorney general and then open her own real-estate law office, becoming the attorney of choice for numerous entertainment and sports personalities purchasing property in South Florida, including players from the Miami Dolphins, Miami Heat, and Florida Marlins, among many other luminaries.

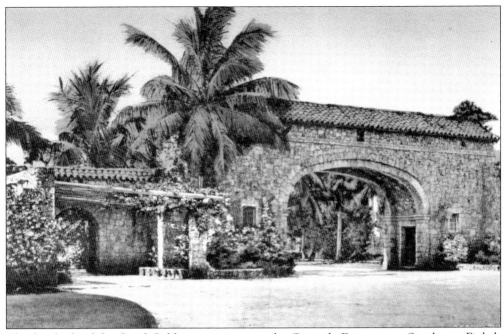

The first-built of the Coral Gables entrances was the Granada Entrance at Southwest Eighth Street and Granada Boulevard. Charles Merrick, George's brother, supervised the building of this unique coral-rock structure. This entrance, suggested by a Spanish entry gate in Granada, is 300 feet long and 40 feet wide and includes pergolas on each side on the entrance with accompanying seats and fountains.

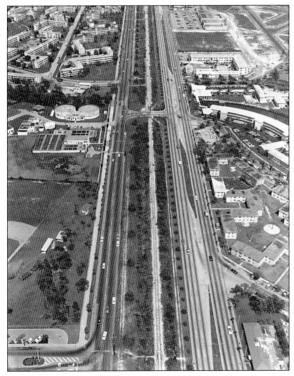

Looking north from just over the Howard Johnson's (lower right) in this March 16, 1965, photograph are, from bottom to top on the right, an apartment complex occupied mostly by UM students, the University Inn, the Holiday Inn, and the shopping center shown at an earlier stage of its life on page 104. On the lower left is the UM baseball practice field that would eventually become the baseball team's Mark Light Stadium, above which is the university's water plant and tanks and the "old" dorms. Every bit of the unoccupied land in the photograph has been built on. The highway on the right is South Dixie Highway, on the left is Ponce de Leon Boulevard, and the Florida East Coast Railway tracks are in the center. The tracks are now gone and replaced by the elevated structure of Miami-Dade's rapid transit system. Finally served by rail, each train stops at the university station.

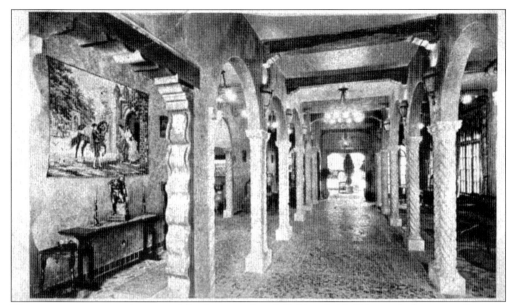

This stunning postcard is one of the famous "Coral Gables Golds." It is only fitting to illustrate the level of quality and beauty that were the hallmark of the founder. There is no record of the exact date of publication of these cards, but they were probably issued in 1923 or 1924. Illustrating various Coral Gables scenes, their uniqueness and rarity have made them a prized item for South Florida collectors, and this one especially is important because it shows the reception room of the administration building and sales office, making it a highly prized piece of Gables memorabilia.

In January 1967, the surviving members of the Merrick family, along with the man who refused to sell the property at 907 Coral Way unless it was preserved as a monument to the founder, posed for a group photograph. It was a long and arduous battle, but the city administration, coming to their senses after being badgered and cajoled by a citizenry distraught at the prospect of losing the home Merrick had grown up in, finally realized that it was incumbent upon them to save the house, which is now known as the Coral Gables House and is maintained in its original state. On the front steps of the house are, from left to right, Mrs. Charles E. Merrick; Charles E. Merrick; Lula Mclendon and Helen Bond, both George's sisters; W. L. Philbrick, the man to whom the people of the city should be eternally grateful for his great act of generosity and caring; and Richard Merrick, George's brother.

In closing the Coral Gables story, it is important to honor the memory of Coral Gables' legendary founder and most important historical figure. It was he who planned, built, and oversaw the birth and growth of his beloved city, and it is he who was and is and will always be the real and true and only "Mr. Coral Gables," George Edgar Merrick.

Seven

SOUTH MIAMI
Enhancing the Neighborhood

The city of South Miami is Coral Gables' eastern and southern neighbor, and in addition to sharing a border, the two cities have much in common, from excellent schools and renowned health care facilities within their boundaries to fine shopping areas and beautiful residential neighborhoods. What they do not have in common is their histories!

South Miami began life as Larkins, named for Wilson A. Larkins, who, with his family, moved to Jennings—which later became Tahiti Beach—in 1897. Two years later, on July 6, 1899, the Larkins post office was created. From there, Larkins and others moved west to be closer to the Florida East Coast Railway as it extended its tracks farther south into Dade County, taking the name Larkins to the new settlement.

After much discussion and with developers urging that a name that reflected the town's location be used, the citizens voted 41 to 25 in May 1926 to change the name of the community to South Miami. On June 24, 1927, the town of South Miami became a city. Unfortunately, for the next four years, there was a great deal of political bickering, and on June 16, 1931, the residents voted 184-163 to abolish the city and surrender its charter.

There was, however, a fly in the ointment: a state court ruled that because the city had not paid for the $4,150 fire truck it had ordered, and that the commitment had to be honored, the city was reinstated on April 2, 1932. In June 1933, its jurisdictional area was reduced from six to three-and-a-half square miles.

Today with a population of approximately 10,500 people and an area of now two-and-a-half square miles, the city is a vibrant, multi-cultural community with a strong and active business segment and chamber of commerce, shopping areas, office buildings and restaurants along U.S. Route 1, and two upscale shopping streets within its boundaries: Red Road and Sunset Drive. South Miami Hospital, a major regional health care facility, is a leader in both health care and medical education and is the largest employer in the city.

Beautiful homes, houses of worship, fine grade schools, community-sponsored activities, citizen involvement and participation in government, and dedicated and committed city employees, linked with the proximity of the University of Miami and Coral Gables, have made the city a desirable place to live and a welcoming enclave amidst the hubbub and traffic of Greater Miami.

The building housing Denning Seed Company, although today serving other functions, still looks essentially the same. The Florida East Coast Railway tracks are gone, replaced by Miami–Dade County's rapid transit system. Other than that, however, much, including the buildings on the north side of Sunset Drive, still looks the same. Taken either in the late 1930s or very early 1940s, the item of greatest fascination in this photograph has to be Florida East Coast steam locomotive

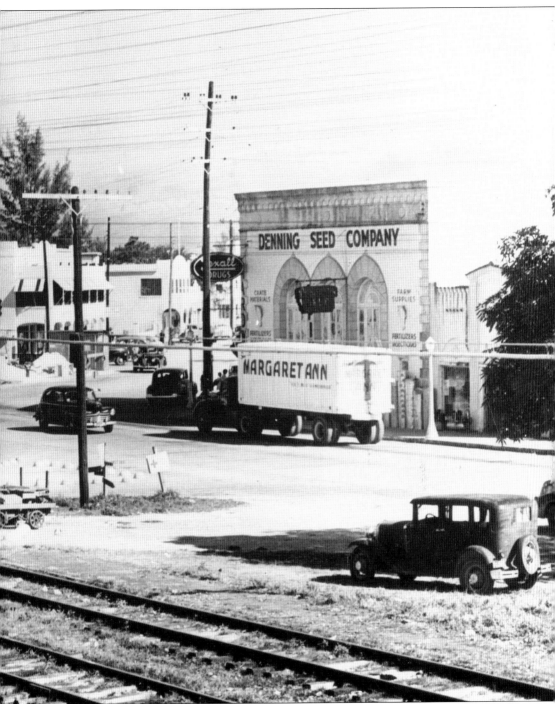

707, most likely stopped at the depot directly behind the first freight car, the station's semaphore prominent behind the utility poles. If taken before July 1941, train 41 is carrying a passenger car along with a baggage and Railway Express Agency car, for this was the last remnant of Florida East Coast passenger train service on this line, which was cut back to Homestead after the disastrous Labor Day 1935 hurricane destroyed 40 miles of the Key West Extension.

A different angle of the Denning Seed Company store, taken in the very late 1940s or early 1950s, shows the building a good bit more well worn. This picture was taken on the northwest corner of Sunset and U.S. Route 1 looking south on South Dixie Highway, with the 1925 Dorn Building (next to Denning) quite evident.

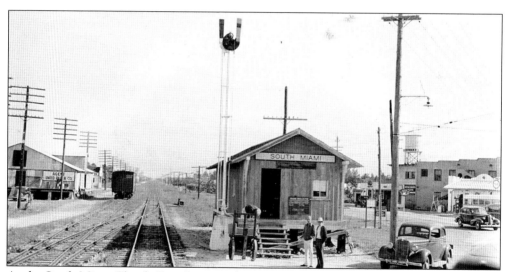

At the South Miami Florida East Coast Railway station in January 1935, this view looks north from Sunset toward Coral Gables. South Dixie Highway is on the right. The water tower on pages 122 and 123 is clearly evident here (to the right of the utility pole, on top of the building in the background), but unlike the previous two pictures in this chapter, there is nothing that remains from this view. Because South Miami was so small at the time, passengers southbound to Key West had to take local trains 41 to Homestead or 42 to Miami in order to board the *Havana Special*, which would take them to the island city.

South Miami Hospital, South Miami's largest employer, stands on the west side of South Dixie Highway and on the south side of Sunset, encompassing several square blocks. Part of the Baptist Health System, the hospital is renowned for both its level of care and its highly rated employee relations. This view looks east, with South Dixie Highway behind the two large buildings. The area shown as a parking lot is now a hospital building, and a new multistory parking garage was constructed several years ago.

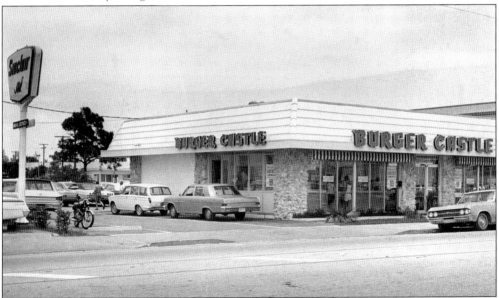

Burger Castle was a name put together from two Miami-founded hamburger chains, Royal Castle and Burger King, and though the Burger Castle stores were short lived (most of them becoming Burger Kings) they are warmly remembered. This store, on Red Road, was a favorite of South Miamians!

This February 7, 1956, image was taken right above the Florida East Coast tracks looking southeast toward the Holsum Bakery complex that, for so many years, was where the Bakery Center/Shops at Sunset Place shopping and entertainment complex now is. Holsum, the 24-hour coffee shop that was the gathering spot for years of UM students, is the free-standing building at center left facing South Dixie Highway. At the time this photograph was made, the highway was being widened from two lanes to four; it is now six. Red Road—Southwest Fifty-Seventh Avenue—is the street running eastward from the lower left corner of the photograph. The fourth intersection on Red Road, east of Dixie Highway, is Sunset.

This ground-level view of Holsum's 24-hour restaurant shows it in all its glory on South Dixie Highway, directly in front of the famous bakery.

HOLSUM BAKERY 1955 HOLIDAY DISPLAY
SOUTH MIAMI ON SUNSET ROAD — EAST OF HWY 1 — DECEMBER 10th THRU JANUARY 2ND

Every year, for many years, Holsum Bakeries founder Charles Fuchs set up a beautiful holiday display, and all of the area's residents were invited to view it. Continued by his daughter, Jane Fuchs Wilson (a major contributor to the Miami Memorabilia Collectors Club and other historic organizations), the displays delighted both children and adults until the early 1960s.

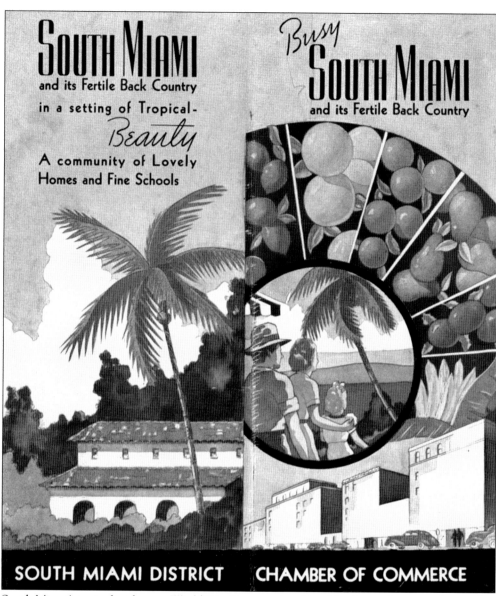

South Miami's immediately post–World War II promotional booklet featured not just the city but nearby attractions, including the Monkey and Parrot Jungles, the Rare Bird Farm, the University of Miami, and more. It is an exceptionally well-done piece and exemplifies all that was (and still is!) good about the area—the South Miami District, as it is referred to on the cover—including the fact that it was still, to no small extent, farm country.

3640